THIS BOOK IS DEDICATED TO
THE MEMORY OF MY FATHER, FRANK

THE COLOURS OF
Southern India

BARBARA LLOYD

THE COLOURS OF
Southern India

 Thames & Hudson

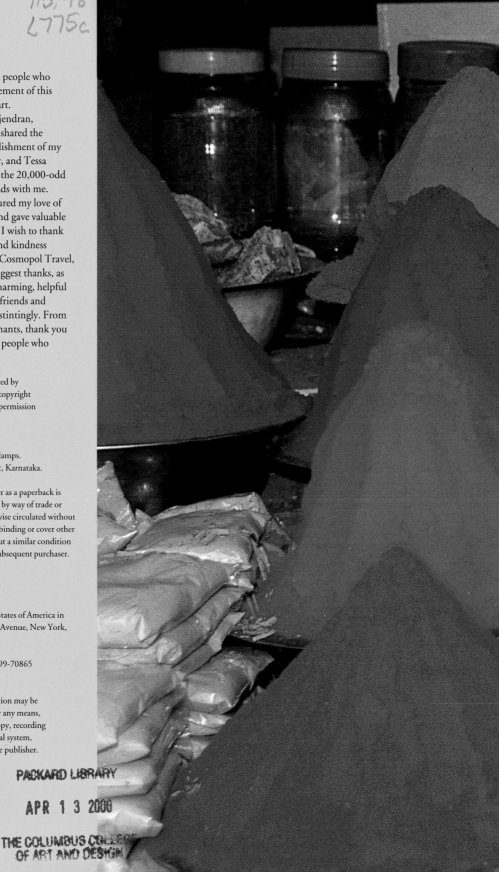

I am indebted to a number of special people who
helped me enormously in the achievement of this
book, which lies very close to my heart.

They are: Louise Nicholson, B. Rajendran,
Ravikumar, and Tessa Solomon. All shared the
trials and tribulations of the accomplishment of my
photographs. Rajendran, Ravikumar, and Tessa
Solomon physically covered most of the 20,000-odd
kilometers of very bumpy Indian roads with me.
George Michell and John Fritz nurtured my love of
the monuments of Southern India and gave valuable
advice on where to go. Additionally, I wish to thank
the following people for their help and kindness
during my travels: Cherian Jacob of Cosmopol Travel,
Rosi Levai, and C. A. Menon. My biggest thanks, as
ever, go to the countless generous, charming, helpful
South Indian strangers who became friends and
extended goodwill and assistance unstintingly. From
the rickshaw pullers to the silk merchants, thank you
all; and thanks especially go to those people who
are the subjects of my photographs.

Eight vacanas from *Speaking of Śiva*, translated by
A. K. Ramanujan (Penguin Classics, 1973) copyright
© A. K. Ramanujan, 1973. Reproduced by permission
of Penguin Books Ltd.

On the half title: *Rangoli* designs.
On the title page: *Rangoli* in the form of oil lamps.
Right: *Dum dum* powders in Mysore market, Karnataka.

© 1999 Thames & Hudson Ltd, London
Photographs © 1999 Barbara Lloyd

First published in paperback in the United States of America in
1999 by Thames & Hudson Inc., 500 Fifth Avenue, New York,
New York 10110

Library of Congress Catalog Card Number 99-70865
ISBN 0-500-28134-3

Printed and bound in Singapore

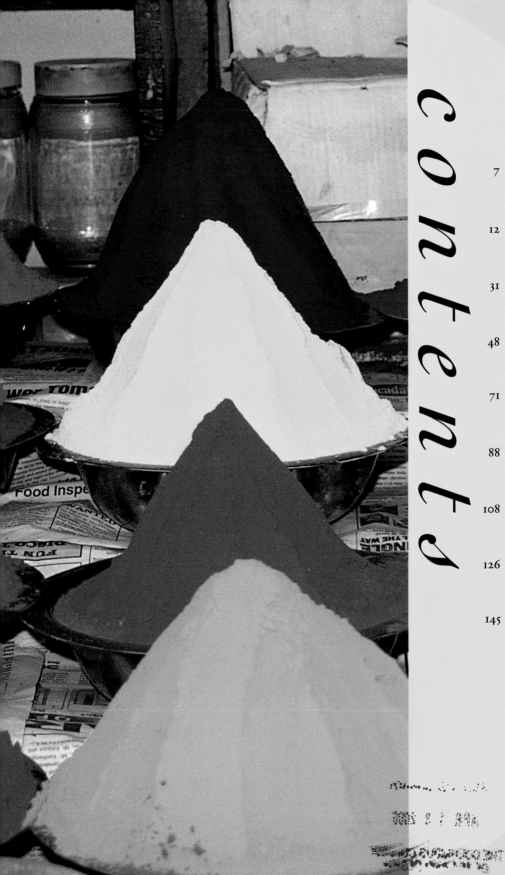

contents

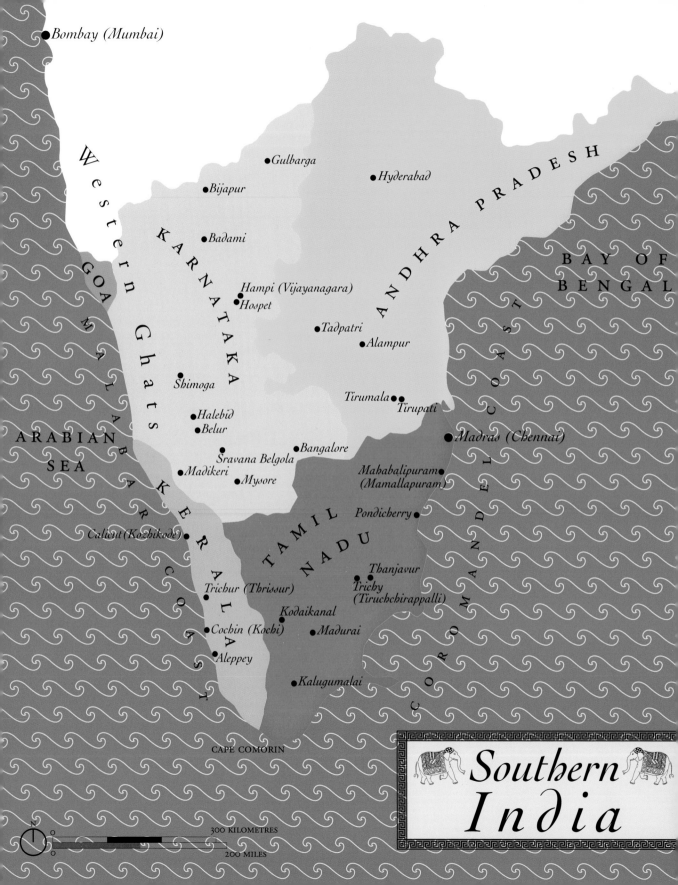

Bombay (Mumbai)

Western Ghats

GOA

KARNATAKA

Gulbarga

Bijapur

Badami

Hampi (Vijayanagara)
Hospet

Shimoga

Halebid
Belur

Sravana Belgola
Madikeri
Mysore

MALABAR COAST

KERALA

ARABIAN
SEA

Calicut (Kozhikode)

Trichur (Thrissur)

Cochin (Kochi)

Aleppey

Kalugumalai

CAPE COMORIN

TAMIL
NADU

Bangalore

Mahabalipuram
(Mamallapuram)

Pondicherry

Thanjavur

Trichy
(Tiruchchirappalli)

Kodaikanal

Madurai

ANDHRA PRADESH

Hyderabad

Tadpatri

Alampur

Tirumala
Tirupati

Madras (Chennai)

COROMANDEL COAST

BAY OF
BENGAL

Southern
India

N

300 KILOMETRES

200 MILES

Foreword

Many thousands of kilometres away from the famous sights of the North lie the Southern States of India: Tamil Nadu, Kerala, Karnataka, Andhra Pradesh and tiny Goa. For the first-time visitor to these states, a great and immensely pleasant surprise awaits. Here, nestled between the Malabar and Coromandel Coasts, lies a land rich in experience, olfactory and visual. Water is plentiful in some areas, and thus the land smells sweet; flowers abound, the rice paddies are fertile and green, palms sway in the breeze fully laden with ripe fruits of many kinds. On the other side of experience is the profusion of wonderful artistic creations that are remnants of countless rulers' patronage and commitment to art, in the form of innumerable edifices – from the Chalukya dynasty of Badami, in the predominantly Muslim northern region, to the Pallavas in the South and subsequently the Cholas and the Hoysalas. They all left their mark in the form of exquisitely carved temple structures of the most intricate and beautiful kind – testaments to the vision and refinement of these long-gone civilizations.

From the Shore Temple and the monolithic Pancha Ratha temples at Mahabalipuram (Mamallapuram), exquisitely plastic in the soft early-morning light, to the living temple at Madurai with its Chariot Festival, and from the City Palace of Mysore to Bijapur on the Karnataka Plateau, there are innumerable testimonials to the achievement of these enlightened rulers. Every road leads to another gem, be it a small abandoned shrine, a tank in a remote village in Karnataka, unrecorded in any guidebook, or a carved chariot tucked away behind a church in Tamil Nadu, engraved with Christian rather than Hindu motifs.

The South is not only about art and architecture (although no day would be complete without a refreshing stop to admire a carving or some example of perfect architectural balance), it is also about the experience of being in this place. Diana Vreeland wrote, 'Pink is the navy blue of India' – and Southern India is all about hot colours. In the West, we have no idea just how important colour is; we wear our greys and blues and conform, while in India these effervescent colours are the norm.

The markets sizzle with colour; the fruit and vegetables are bright and mouth-watering, their variety and abundance dizzying. Gourds, greens, peppers and chillies, bananas of every shape and size, and fruits of every different type of palm are on sale. Jasmine flowers in never-ending garlands – strings immeasurably long – are cut to the prescribed length in hot and humid flower markets. The air is thick with the musk of millions of petals and buds being made ready for temple and festival offerings. During the Dussera Festival in Mysore, buses, scooters, rickshaws and cows are adorned with marigolds and garlands of every kind.

Top: On the way to Cape Comorin, Tamil Nadu: a cathedral seen through the betel palms.

Above: Wedding in Andhra Pradesh.

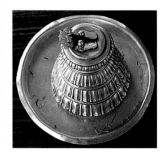

Blessing cone with
the feet of the Lord Buddha.
This is pressed on to the
heads of penitents in
Hindu temples.

This wealth of visual and spiritual experience lies at the very core of Southern India; so let us look quite simply at the significance of the colours in religion. Blue is the representation of the celestial states of Vishnu and Rama. Shiva's state is shown through ash, signifying his term of occupation of this earth. Black is the incarnation of Shiva's wrath. Kali, too, is represented in sculpture in black, although she wears red robes. Hanuman, the gentle, fun-loving monkey-god, is seen through green, as is the goddess Parvati, whose sari is of the same colour. Durga, yet another incarnation of Parvati, is also seen in green. In *Kathakali* dancing, the good persona is represented with green make-up. Lakshmi, consort of Vishnu and goddess of wealth and fortune, wears red, while Sarasvati, the Hindu and Jain goddess of learning and music, is adorned in white robes. Yellow is the colour of auspiciousness, and young brides daub their faces with yellow powder, extracted from turmeric, in preparation for their marriage ceremony. Turmeric supposedly has a healing and cooling property and is widely used.

The experience of entering a temple is also unique for the Western observer. Man prostrates himself in front of the greater being, rings the bell to announce his arrival to the gods, then steps across the threshold of the holy site. His ringing of the bell alerts the temple guardian or priest to his arrival, and thus sets up the process of the reciprocal chant. With eyes closed, hands pressed tightly together, he then perceives the eternal flame, which is represented by small fires made with camphor balls, and his senses are heightened with the odour of incense. As the total experience continues, it culminates in the smearing of ash – white – on the forehead, and thus sublimation is achieved.

Nowhere is this more apparent than at the truly sacred temple complex at Tirumala, on top of the holy mountain overlooking Tirupati. Pilgrims arrive and, as a penance of great import, shave their heads. Indian women, in particular, take extreme pride in their long hair, so being shorn in this way is an extraordinary sacrifice. Afterwards, their heads are smeared with sandalwood paste as a balm against the sun's fierce rays – while their lost hair lies in piles which will be sold to the West for hairpieces and wigs.

Dum dum powder displayed
at market in a beautiful
pyramid.

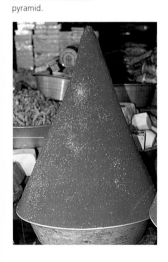

Surya, the sun-god, seen with his seven horses in many Southern Indian temples, signifies the colours of the rainbow. In the intricate powder painting of the tribe who create the labyrinthine *pambin kalam* floor pieces in Kerala, colours are obtained as follows: grey comes from rice powder and charcoal; green from powdered leaves; yellow from turmeric; black from plain ground charcoal; white from pounded rice; red through a combination of turmeric and lime. The creation of this unique art, which is accomplished over hours of cramped contact between the family members, who somehow manage to complete the work without tripping over each other, is in itself an extraordinary experience.

Religions intermingle quite harmoniously in the South, from the predominantly Hindu state of Tamil Nadu to the Catholicism of Kerala, the prevalence of the Muslim faith farther north, and the many references to Jainism. Their interaction is in keeping with the record of

events in the Southern Peninsula, where subjugation and emancipation are repeated throughout the region's history and the evidence of its archaeology.

There is no place to equal Vijayanagara (the spectacular ruins at Hampi) – one of India's best-kept secrets. Here we have evidence of a wonderful civilization of the 14th to 16th centuries, while some features of the landscape can be identified with the *Ramayana* (the epic story of Rama). Here the full moon rising over the Vitthala Temple in the early morning is a unique experience, as exalting as having clambered over rocks to see the carving of Ananta-shayana (Vishnu reclining on the serpent Ananta) hidden amongst the boulders near the river. Why were these carvings made here? We shall never know the answer. Yet the experience must not be missed. Scrawny Vaishnavite *sadhus* resting in the shade of a banyan tree and wonderful *chai* (sweet buffalo-milk tea) await the intrepid explorer as a recompense for the effort.

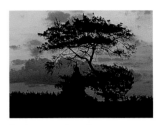

Sunrise: tree and temple outline at Mahabalipuram (Mamallapuram), Tamil Nadu. This is the famous Temple of Dawn.

Dance is prevalent in the South, with many forms becoming ever more rare. The farmers or office workers who perform the *Yakshagana* (celestial dancing) for up to six months of the year for a very small salary display an extraordinary intimacy in the moments before the night-long event starts. Those who appear in the later parts of the *Ramayana*'s recitation take the chance to sleep, fully made up, before their part is called. In the meantime, the audience has settled down to the night's entertainment, with grannies and their families snoozing between acts on rugs and the more affluent equally enjoying the spectacle in the cool of the night between catnaps in the relative comfort of a rented deck-chair. The unique repartee between the actors – with sounds of acknowledgment punctuating the speakers' words – is a wonderful way to spend a night. The epic story finally unfurls as dawn breaks.

On the way to an archaeological ruin in Karnataka, we came upon preparations for a festival, where boys were being painted as tigers in a region that was once populated by the big cats. However, instead of being covered in the natural pigments described earlier, they were being daubed in house and enamel paints. To contemplate the effect on their skins when we learnt that the paint would be removed with kerosene is almost unbearable. These boys will suffer pigmentation problems, with the distressing associated stigma, for the rest of their lives.

Rangoli (painting with flowers and powders) with an added ingredient: cow dung. Andhra Pradesh.

The art of painting with pigment is widespread – in Andhra Pradesh, we saw many different types of this *rangoli* decoration of varying intricacy. From flower petals placed on top of cow-dung patties to elaborate coloured designs of lanterns in the form of oil lamps, these drawings on the thresholds of simple homes are the prerogative of women. At the start of every day, the matriarch of the house begins with a simple design in rice powder on her front doorstep. The dusty path leading to the house is next wetted down with cow dung. Then the powder is traced in a single uninterrupted line as a representation of meditation or prayer. The dried dung has a dual purpose: it is also an insect repellent.

In the middle of nowhere in Andhra Pradesh, we came upon an itinerant *sadhu* on a bicycle – his mobile home and temple for many years. Extraordinarily, this holy man was totally

receptive and friendly towards a group of Muslim boys, who were residents of an orphanage by the roadside. Swami Rameshwar Das was on his way to Ayodhya in Uttar Pradesh (Central North India) and would probably reach home in about three years. We gave him a plastic water bottle and a packet of biscuits and off he went in the opposite direction. We would reach our destination a lot faster than he.

In a very remote temple in the village of Uttara Kosa Mangai (Tamil Nadu), we were fortunate to witness two extraordinary events. Normally, the temple goddess is only attended to and dressed by Brahmin priests, but in this far-flung spot, where the 16th-century incarnation of Parvati (Mangala Devi) was being made ready for her wedding to Shiva, we were honoured to be able to observe the ritual. Her eye make-up was being intimately applied by an arthritic attendant, her lips, eyeliner and beauty spots being formed of moulded, coloured wax. Meanwhile, outside the temple, a *mahout* was equally lovingly and attentively applying softened chalk to his beautiful young elephant, which patiently swayed from pad to pad while he finished his work.

Temples feature predominantly in the South, among them Madurai, on the south bank of the Vaigai River, which served as the capital of the Pandyas during the 7th to 13th centuries. With its many *gopurams* (towered temple gateways) guarding the main temple complex, it is a wonderful stage setting for the annual Chariot Festival. The two main chariots, which tower some 10 to 20 metres (30 to 60 feet) in height, represent Shiva and Meenakshi. These solid carved-wood structures, mounted on enormous wheels, are towed around the temple's circumference by thousands of white-clad pilgrims on huge ropes to the chant of Brahmin priests directing them by drumbeat and voice.

Farther south, in the town of Trichur (Thrissur), another festival unfolds during the hot weeks preceding the arrival of the monsoon. This is the annual Pooram Festival, in which the temple elephants compete against each other, not in terms of physical prowess (although this is where it originally came from), but in decoration. The elephants' accoutrements are displayed in the equivalent of town halls, while later in the day the elephants, their *mahouts* (lifelong minders) and Brahmin priests parade and exhibit the full extent of their finery. By the end of the day, the centre of town is awash with excited black-haired 'boys' cheering each team on. Hundreds of thousands of men come from all over Kerala to attend this festival, which is rounded off with the most extraordinary firework display. At about 3.00 a.m., a series of mortars are released from holes dug in the central park, after which competing temples start again trying to outdo each other. Even prepared with earplugs, it seemed to resemble a wartime air raid. The fainthearted fled to their hot and steamy rooms.

Mysore, too, has a celebration of great intensity – Dussera. At night, the whole city is lit up with millions of fairy lights, and every means of transport – bus, truck, car, rickshaw, bullock cart or donkey – is decorated. Garlands of flowers, rice painting and stick-ons are the norm.

The two temples at Kovil, near Madurai, Tamil Nadu.

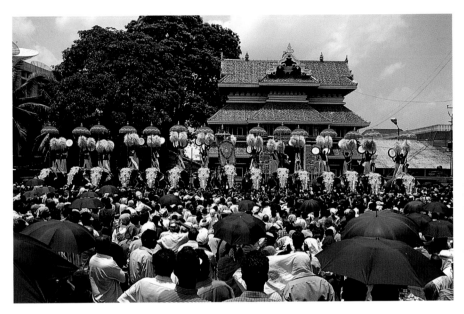

Crowds of people in front of one of the competing temples in the Trichur (Thrissur) Pooram Festival in Kerala. Each temple vies for the loudest applause and most deafening cheers for its elephants' decorations.

Homes are illuminated with Christmas-like decorations, with nativity settings of Christian, Hindu and uniquely personal altars. The 'Maharaja' features in many of them.

Every southern capital boasts some kind of festival, and there is no way to avoid a celebration if the body is willing. Although struggling through masses of predominantly male Indians can be taxing, the end result is most rewarding and one must never be afraid – follow the trail of humanity and a treat might well be waiting.

There are corners in this southern hemisphere that remain untouched by the West and television. In a mountainous area around Shimoga (Karnataka), we encountered something totally unique: blessings to the higher powers for bountiful crops. This was the Bhoomi Hunnime Festival, occurring once a year during a full moon. 'Dressed' rice grass and betel palms become shrines of a personal kind in the form of women, the trees wearing saris and the rice being tied with coloured cloth.

These few words can be no more than an inadequate attempt to describe an incomparable experience – Southern India is a place apart. Its smells, architecture, festivals, people, dress and food can provide an intimate, exhilarating and uniquely life-enhancing adventure. Enjoy it.

The poems on pages 12, 31, 49, 71, 89, 108, 126 and 145 are from *Speaking of Śiva*, a collection of *vacanas*, or free-verse lyrics written by four major saints of the great *bhakti* protest movement which originated in the tenth century AD. Composed in Kannada, a Dravidian language of South India, they are lyrical expressions of love for the God Shiva, concentrating on the subject rather than the object of worship and expressing kinship with all living things in moving terms.

red

Sunsets and sunrises, like
the *tikka* dots on women's
foreheads. Red paste and flowers
in the market. Religion and life
together joined. Passion and
fruit, weddings and the *henna*
designs on the palms of girls
about to be married. The start
and end to a perfect day.

Looking for your light,
I went out:

 it was like the sudden dawn
 of a million million suns,

 a ganglion of lightnings
 for my wonder.

 O Lord of Caves,
 if you are light,
 there can be no metaphor.

ALLAMA PRABHU 972

RIGHT
Trichur (Thrissur), Kerala,
during the annual Pooram
Festival. One of its many
temples is lit up at night
during the festivities.

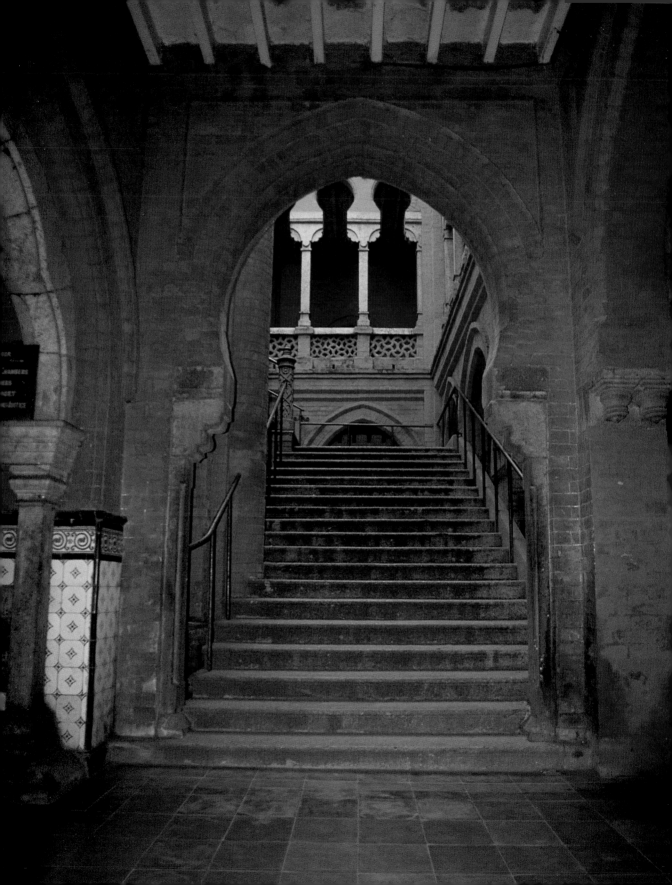

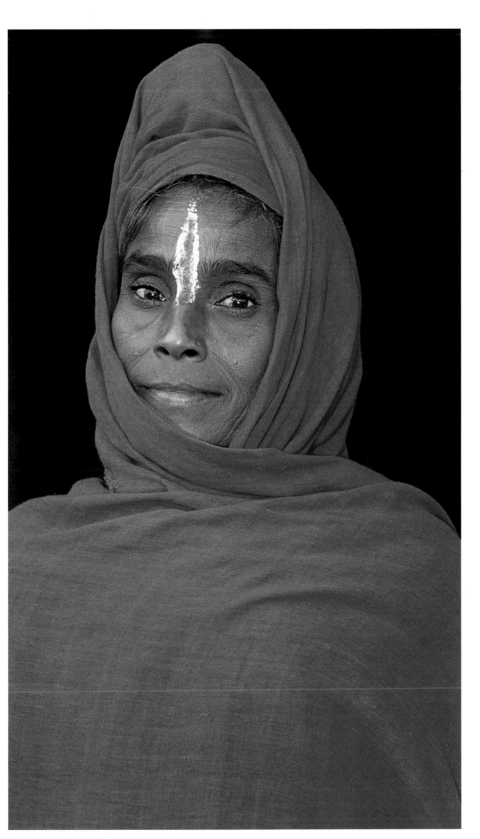

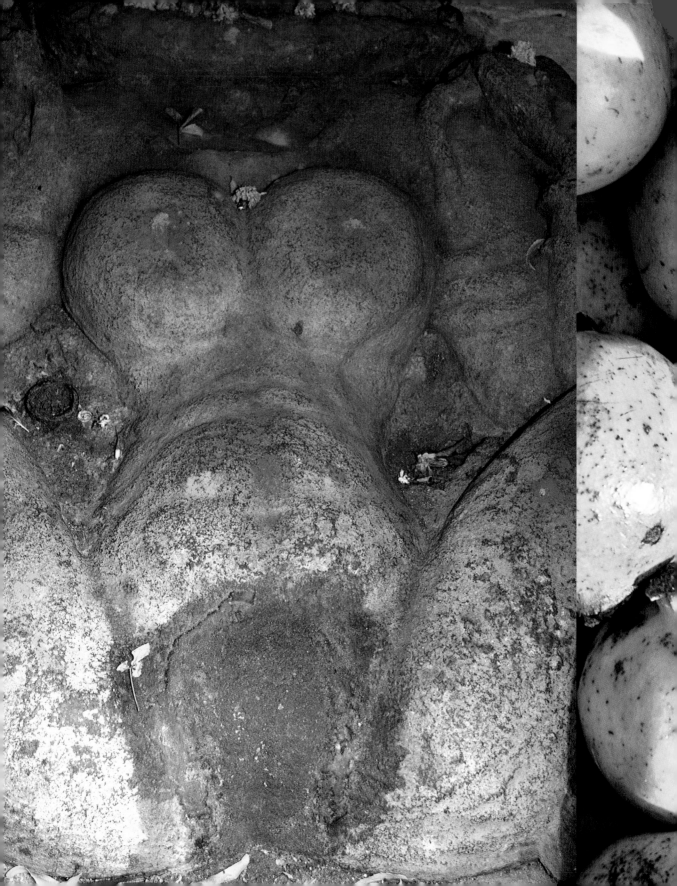

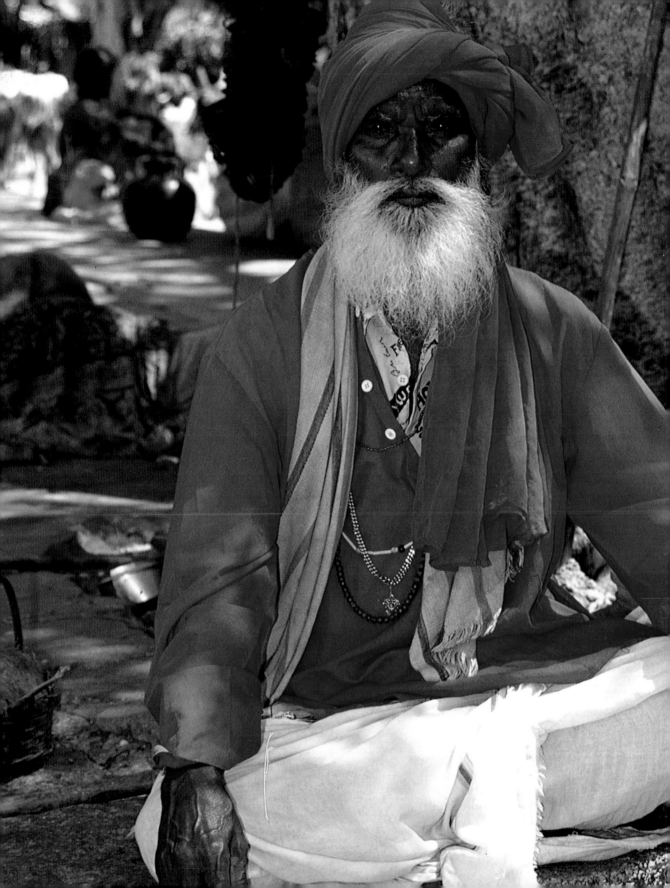

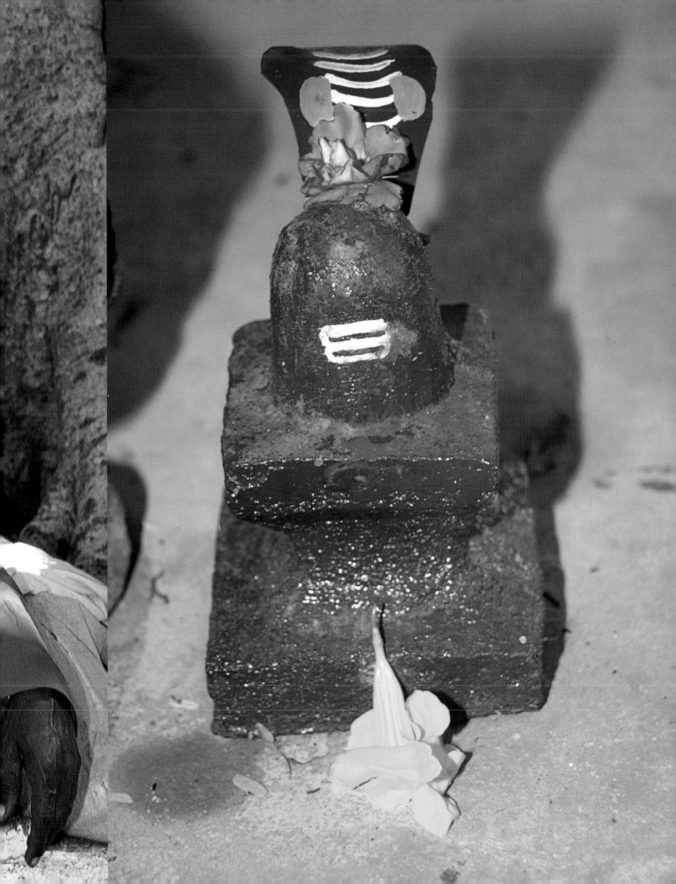

PREVIOUS PAGES

(LEFT) *Sadhu* meditating
beneath a holy banyan tree.

(RIGHT) A temple *lingam*
(phallic emblem representing
Lord Shiva) adorned with
petals and powder.

RIGHT

A young boy undergoing
initiation rites into becoming
a Brahmin priest.

OPPOSITE

Boy of the Ezhaviar caste
(transvestite eunuchs)
at the Kanchukalangra
Festival, Kerala, dancing
to exorcise demons from
the child in his arms.

OVERLEAF

1 Firework posters
depicting various deities.

2 The feet of the
Lord Buddha strewn with
flowers and powder.

3 These symbols are often
found outside temples: they
represent the feet of the Lord
Buddha and are always
decorated with petals and
dum dum powder.

4 Berries.

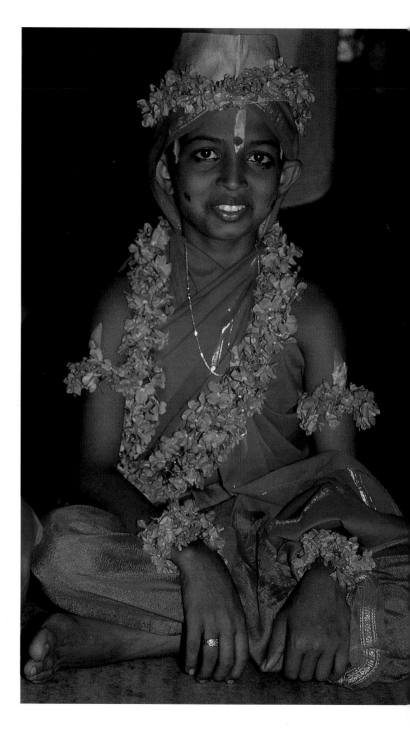

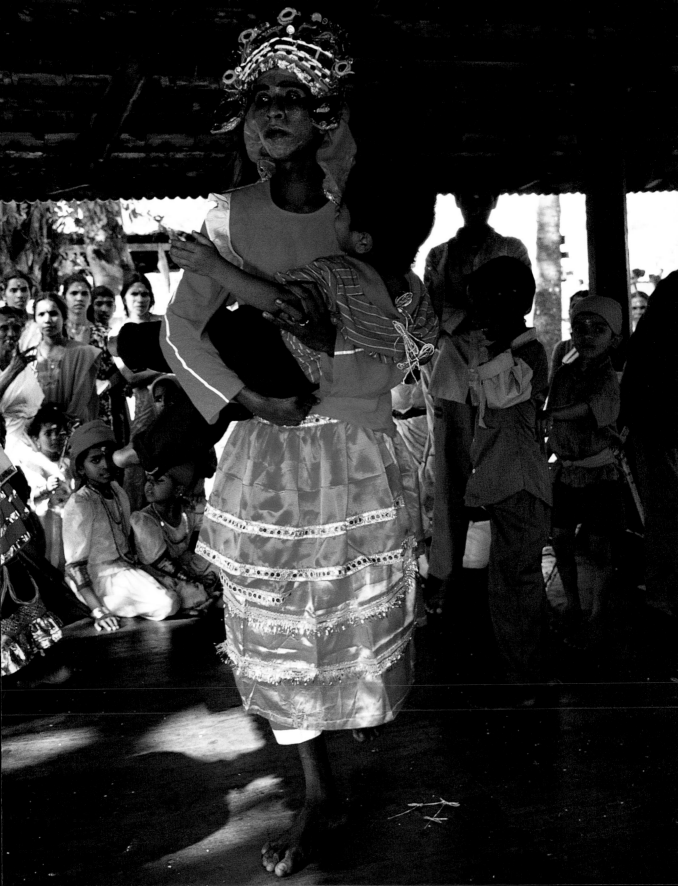

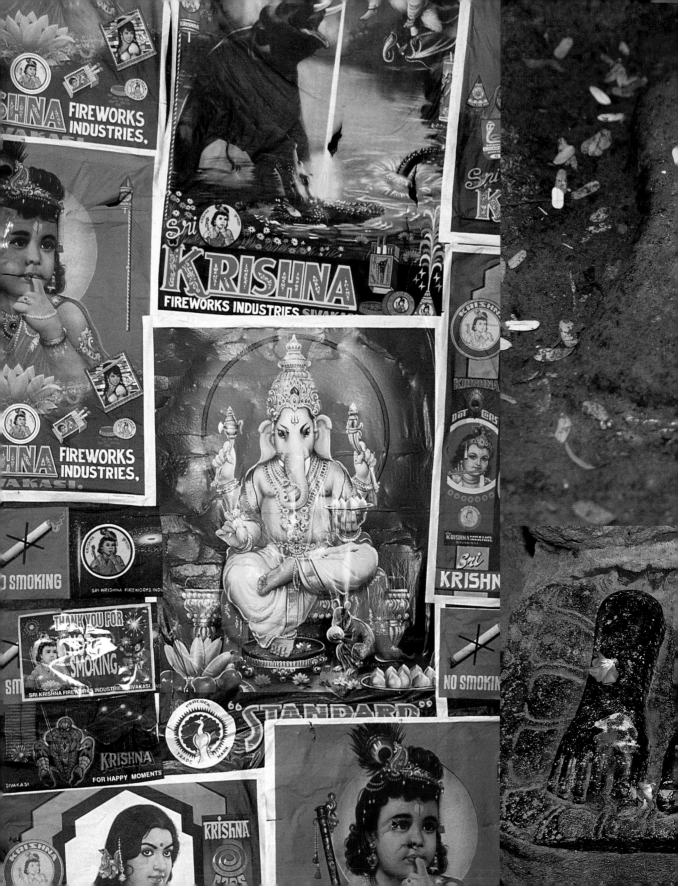

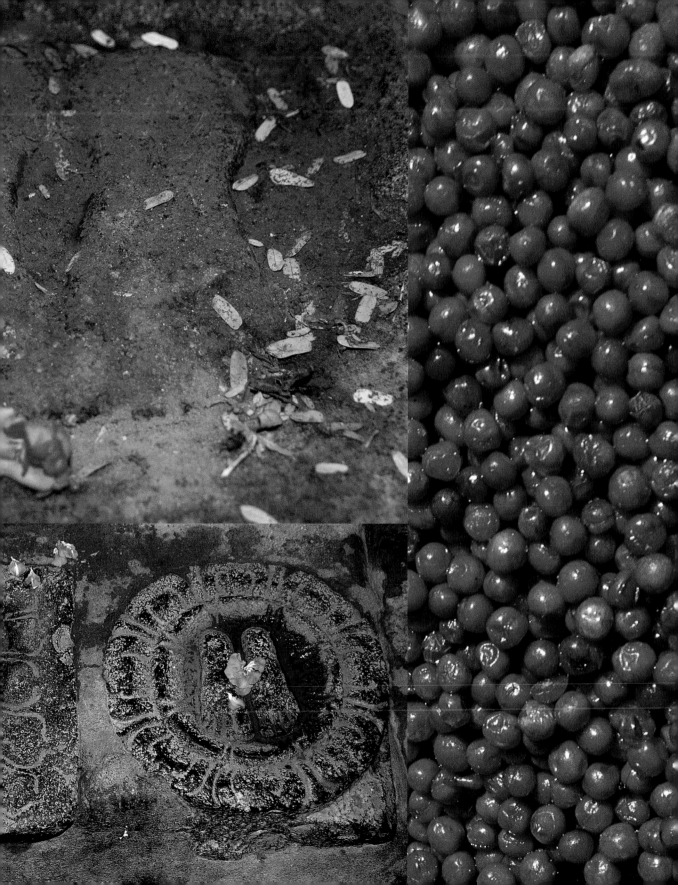

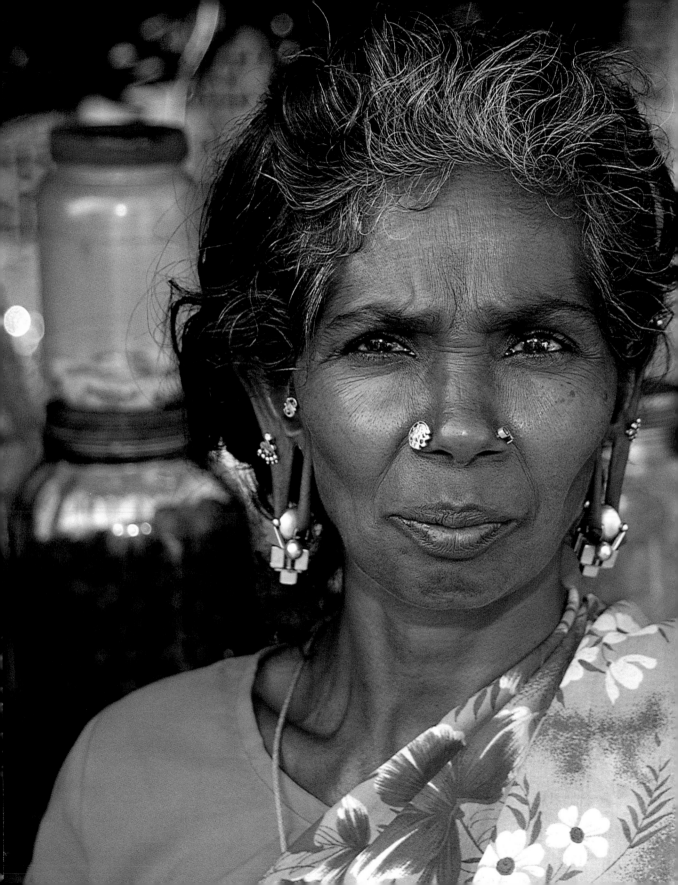

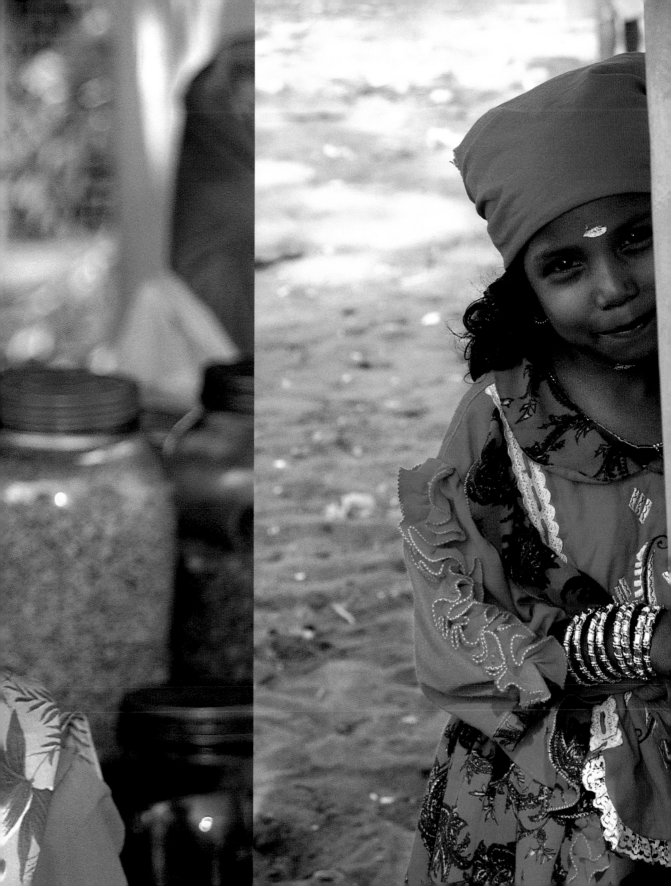

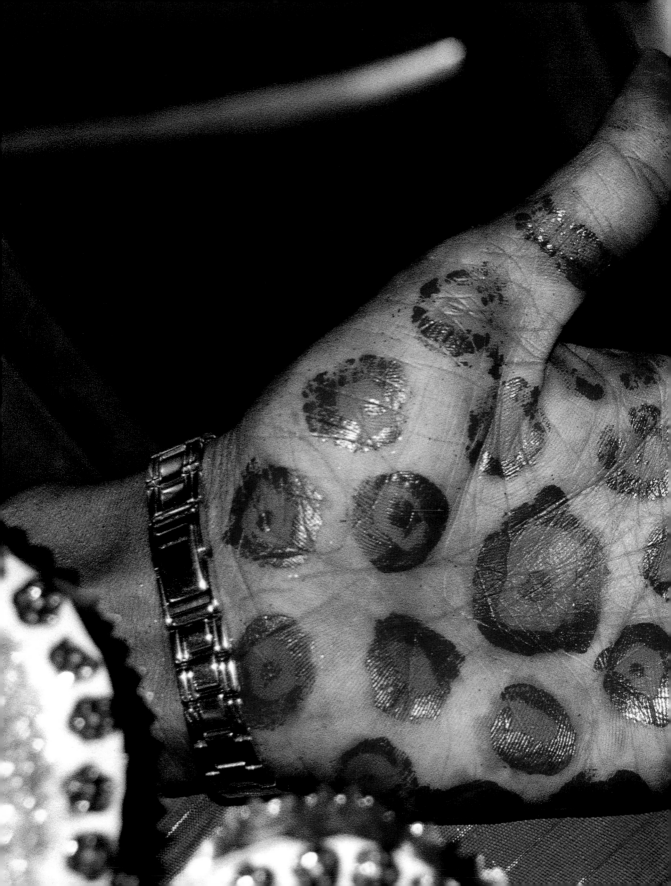

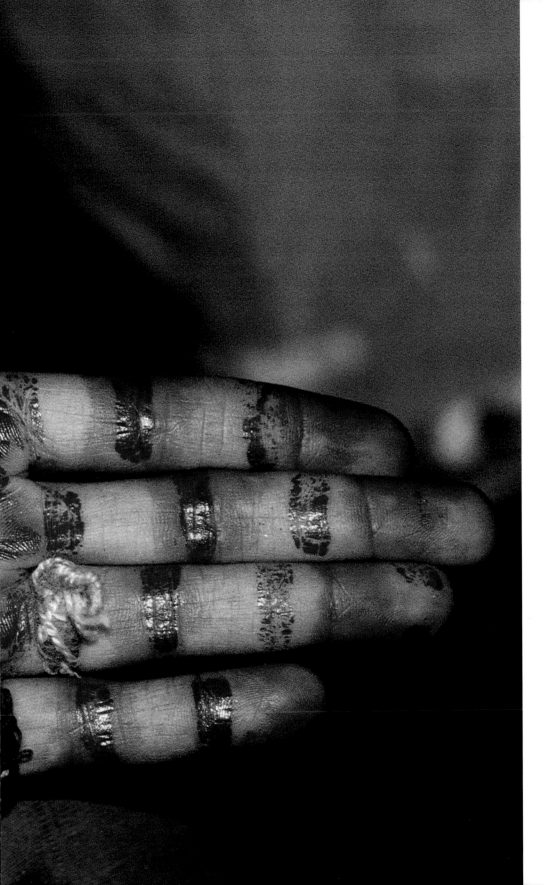

PREVIOUS PAGES
(LEFT) Elderly tribal woman with extended earlobes. She is not widowed, for then she would have had to discard her jewelry and would sport large, empty, dangling lobes.

(RIGHT) Tribal girl at the Kanchukalangra Festival, Kerala.

LEFT
A bride's hand decorated with *henna*.

OVERLEAF
(LEFT) Girl carrying dyed straw.

(RIGHT) This old holy man is carrying a *koveri* – a portable shrine.

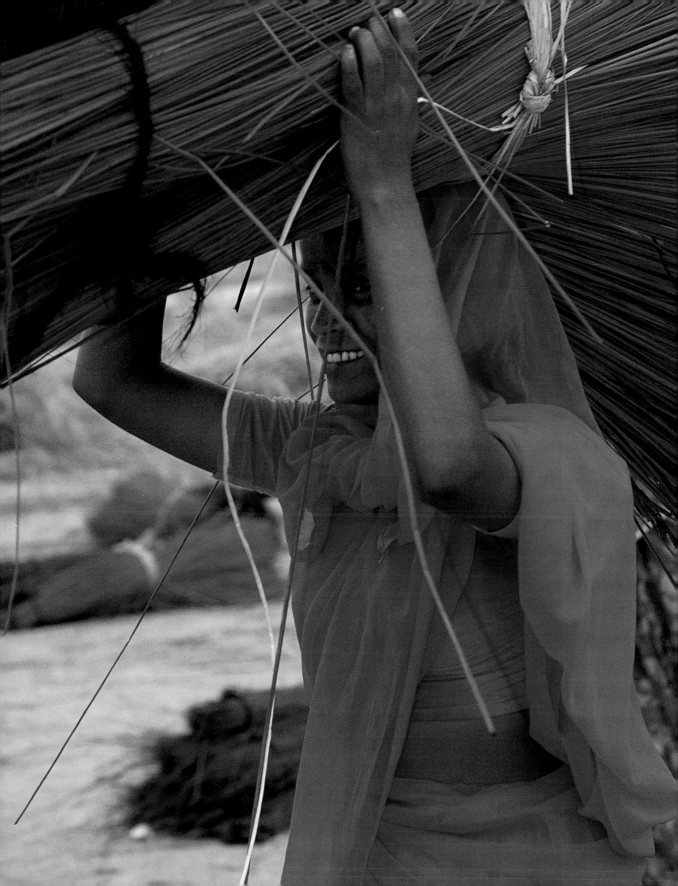

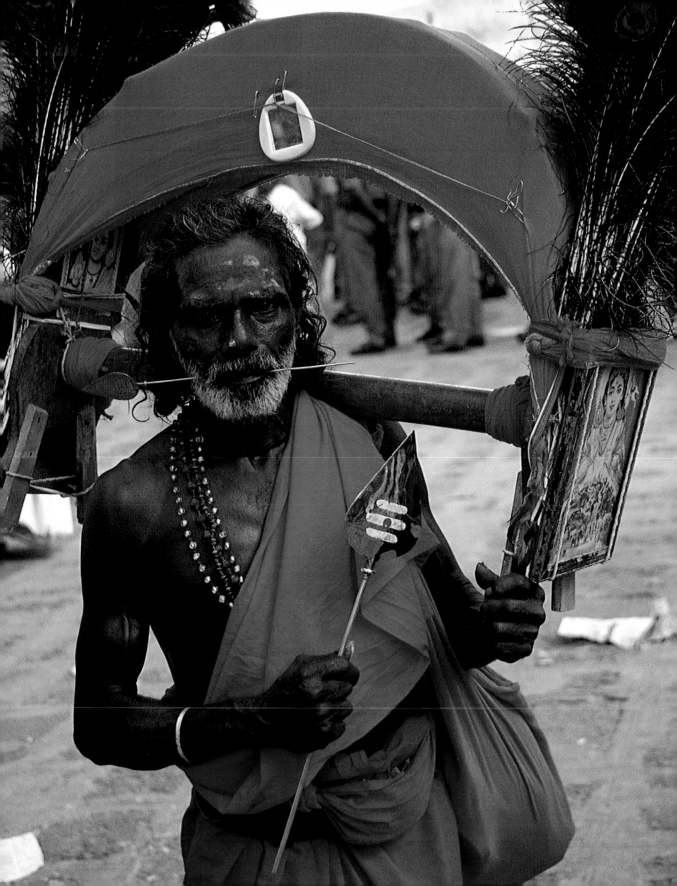

yellow

Warm three-dimensional light
of the early post-dawn and
pre-dusk hours. Flowers and
grains, saffron and turmeric for
decoration. Adornment for the
Lord Buddha's feet. Lemons for
use in *pujas* for fertility prayers.
Hope and devotion.

He'll grind till you're fine and small:
He'll file till your colour shows.

> *If your grain grows fine*
> *in the grinding,*
> *if you show colour*
> *in the filing,*

then our lord of the meeting rivers
will love you
and look after you.

BASAVANNA 686

LEFT
Banana fritters being fried
in the market.

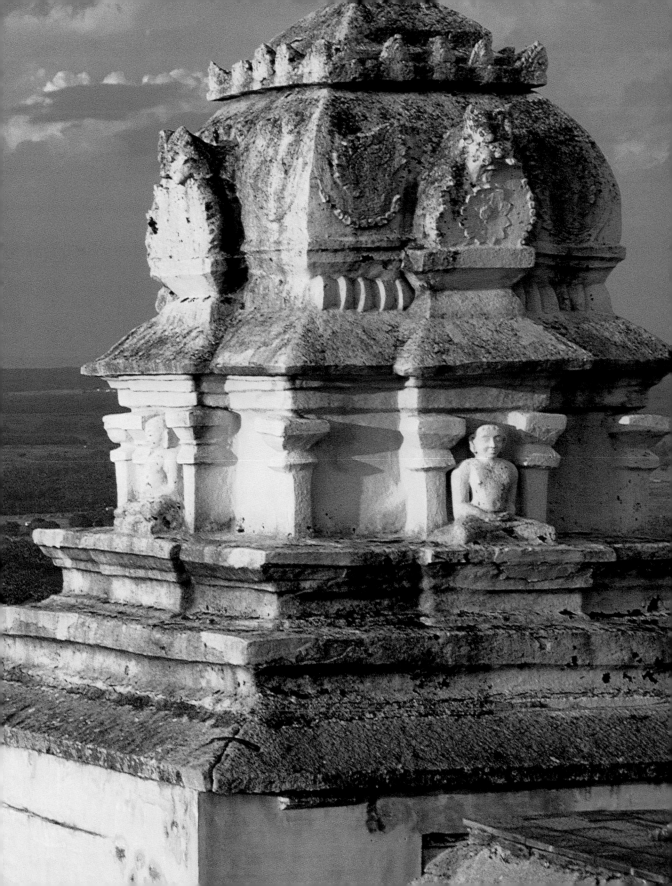

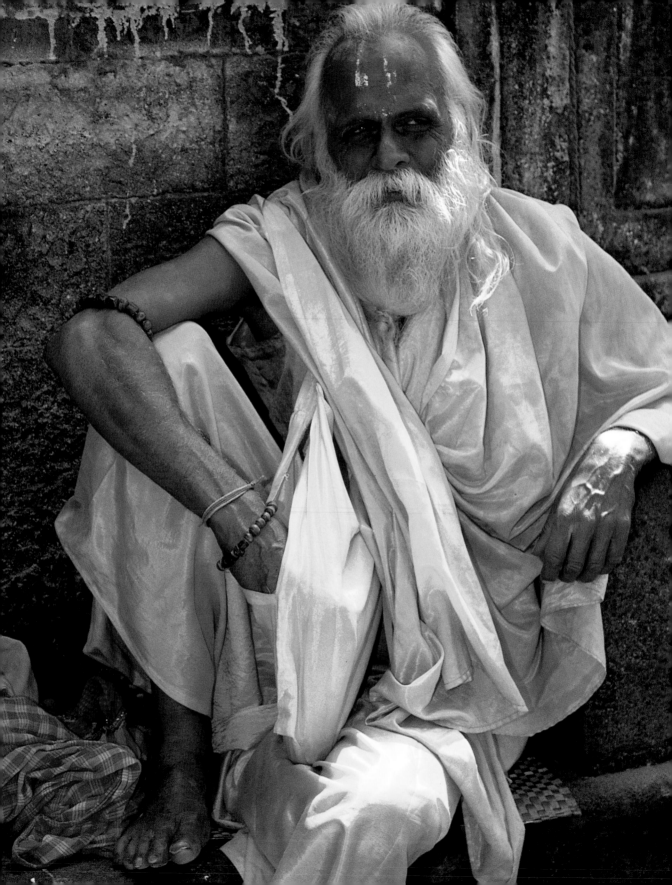

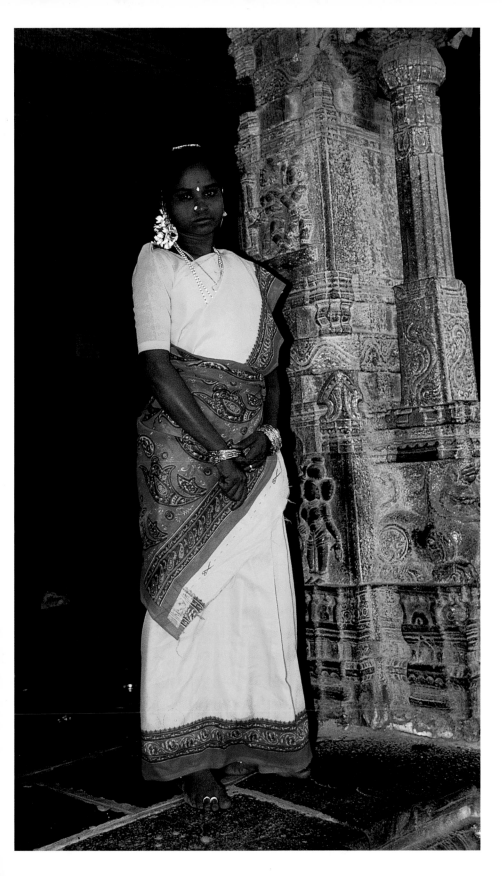

PREVIOUS PAGES
(LEFT) Jaggery (coarse
sugar made from palm
sap) in the market.

(RIGHT) View from the top of
the Jain temple at Sravana
Belgola, Karnataka.

OPPOSITE
Holy man in Bombay
(Mumbai), Maharashtra.

LEFT
Tadpatri, Andhra Pradesh.
This young girl has just got
married and is hanging
around the Chintala
Venkataramana Temple
with her friends.

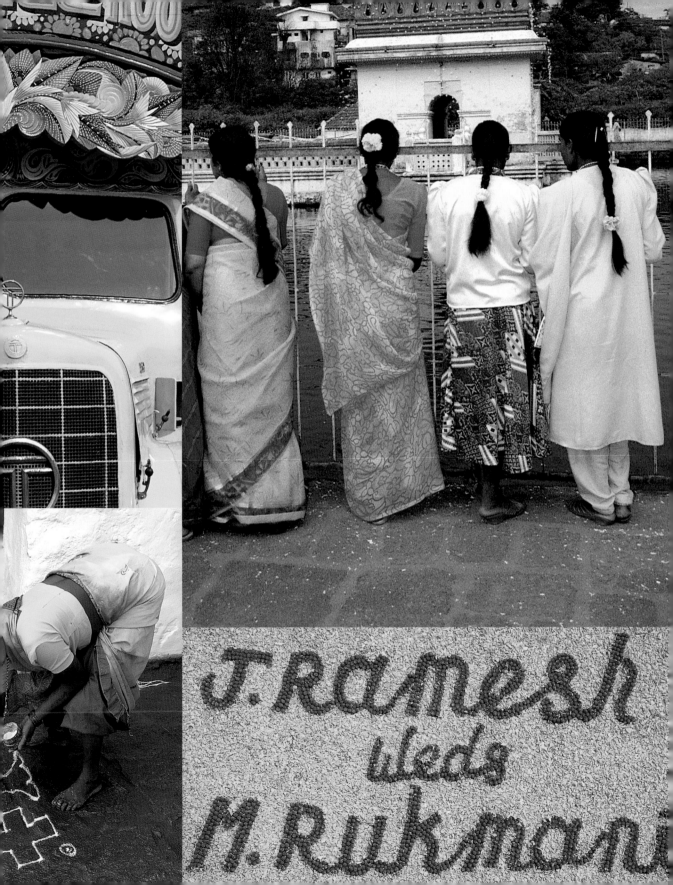

PREVIOUS PAGES

1 Detail of the interior of the tomb (*gumbaz*) of Tipu Sultan at his old Summer Palace, the Daria Daulat Bagh, just outside Mysore, Karnataka.

2 Trucks in Kerala are decorated with wonderful slogans and paintings – each one different.

3 This woman is performing the morning ritual of *rangoli*, decorating her doorstep with white rice powder as a form of contemplation.

4 Women gazing at the temple tank in Madikeri, Karnataka.

5 Announcement in marigolds of the wedding of Ramesh to Rukmani.

RIGHT

Holy man travelling throughout India on a bicycle – he had been away from home already for four years.

OVERLEAF

Silkworm cocoons are grown in these specially constructed woven circular trays.

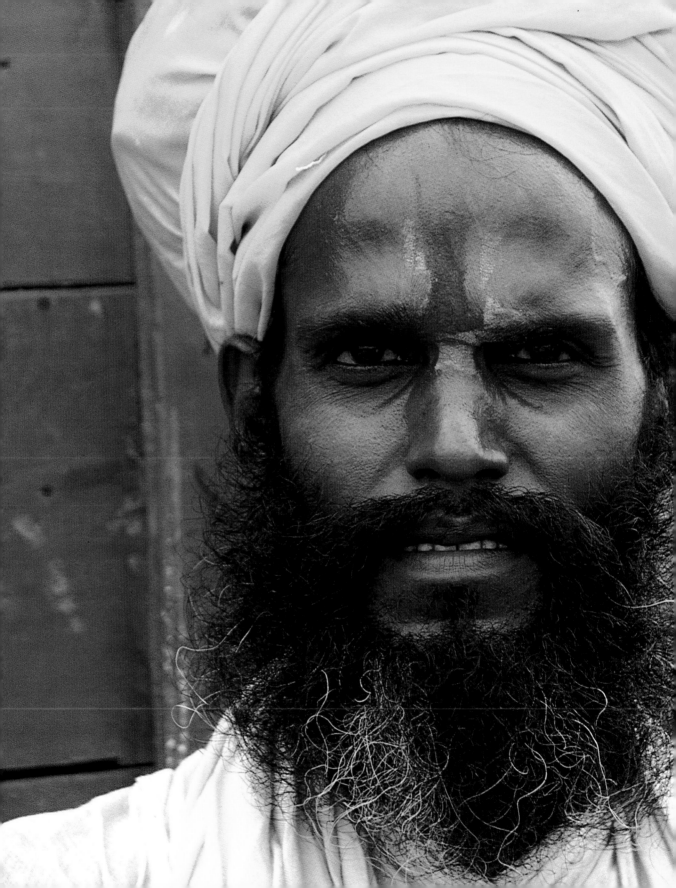

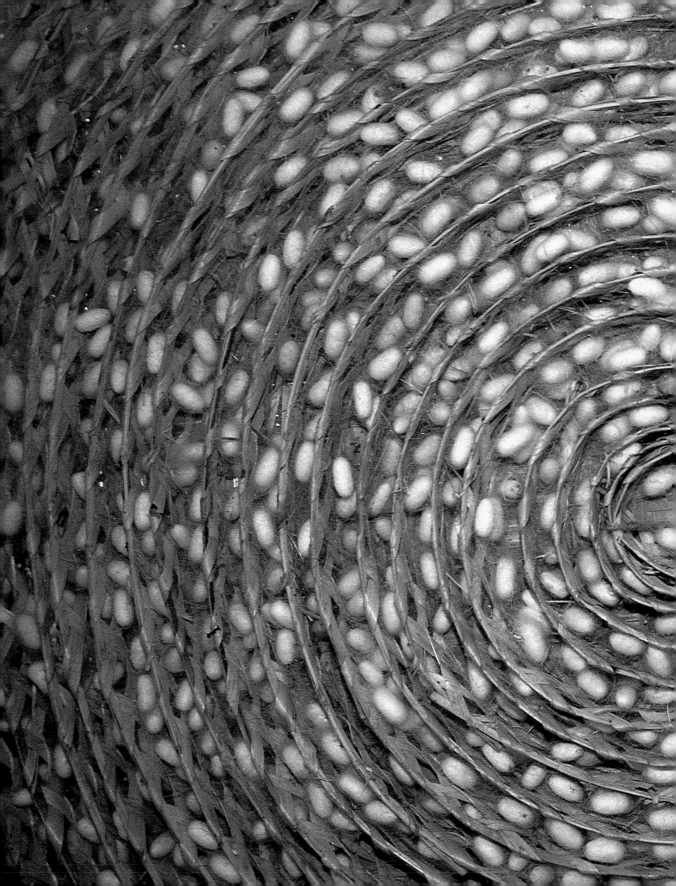

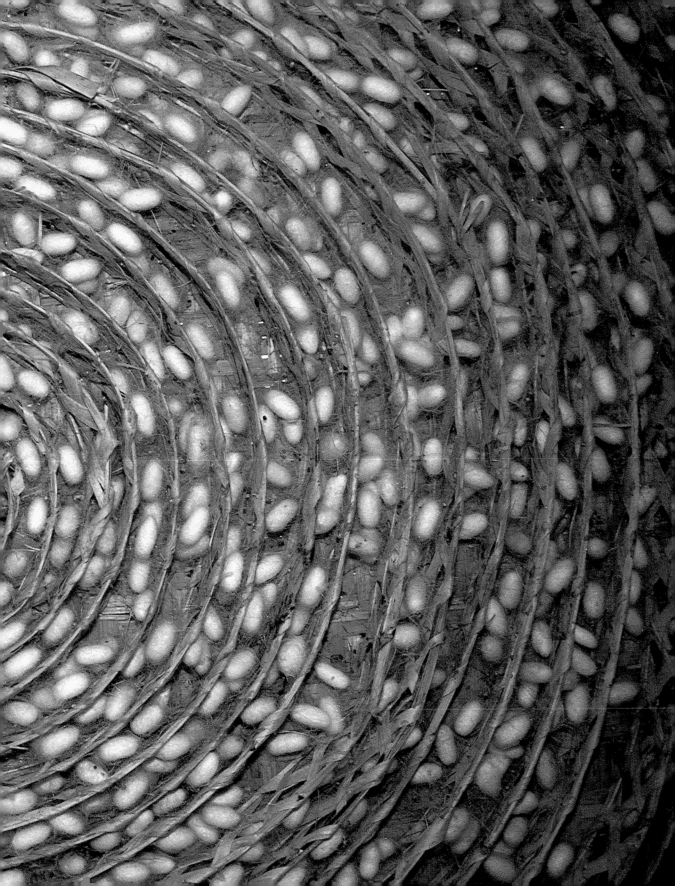

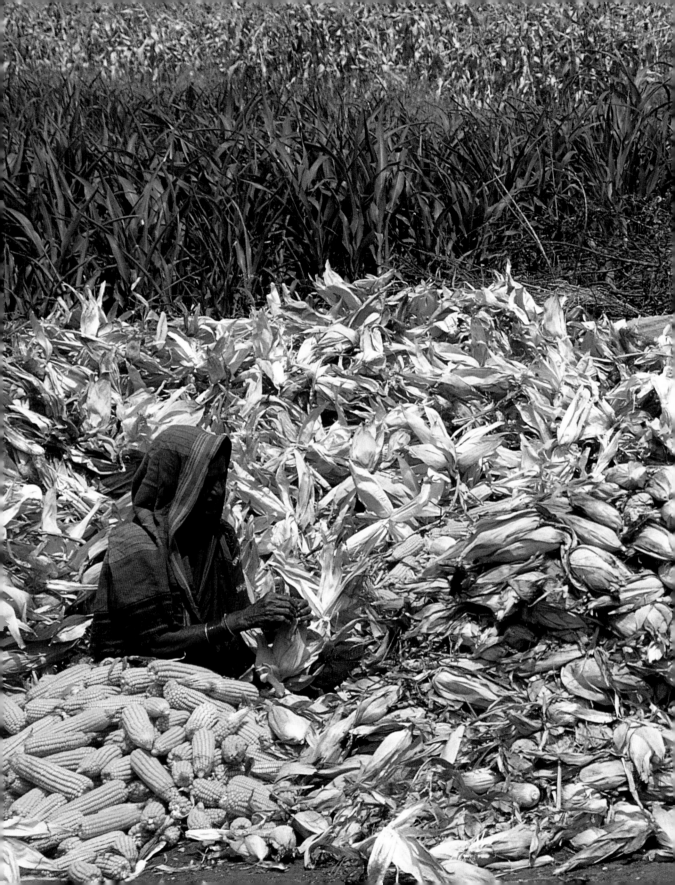

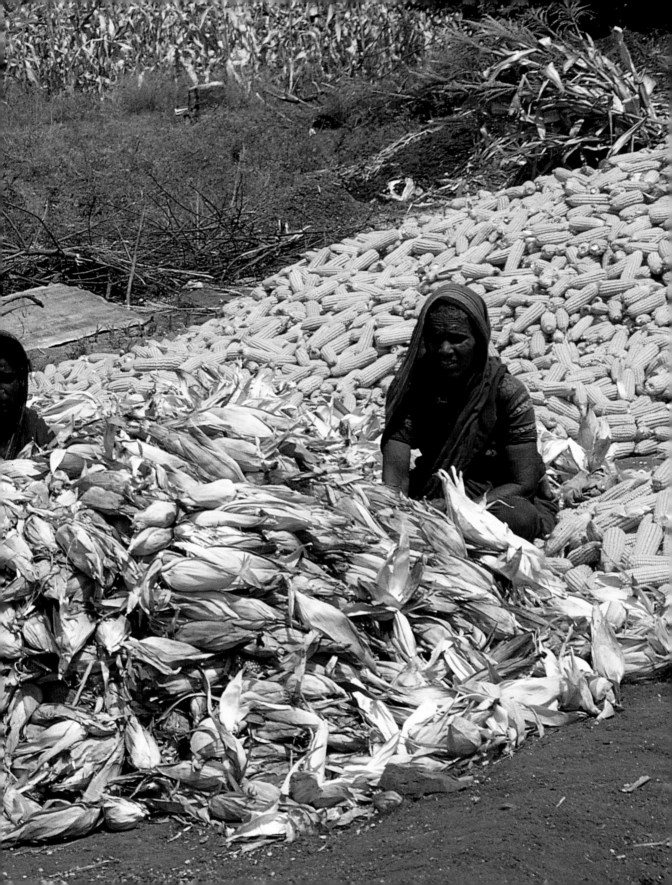

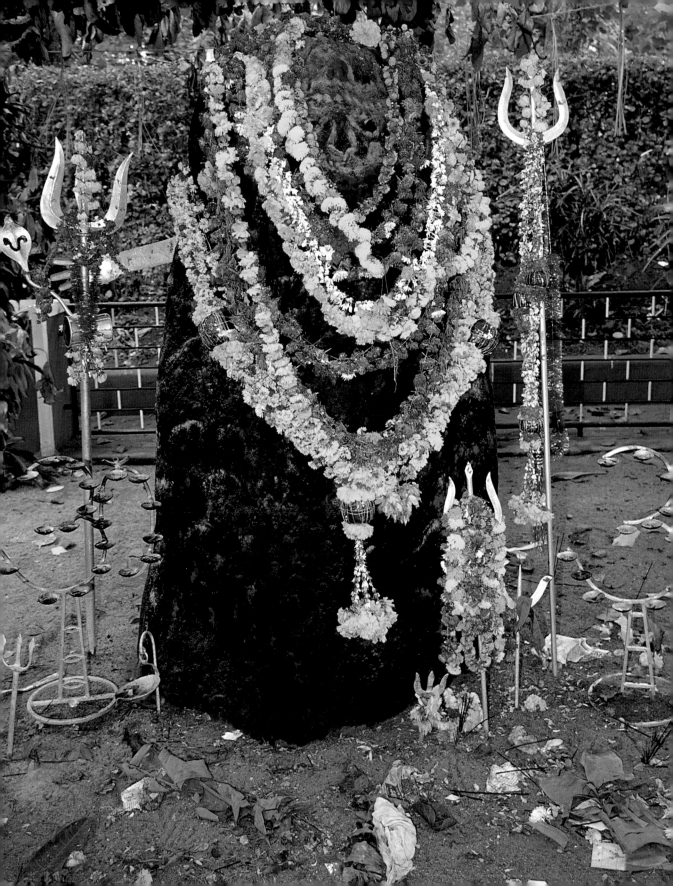

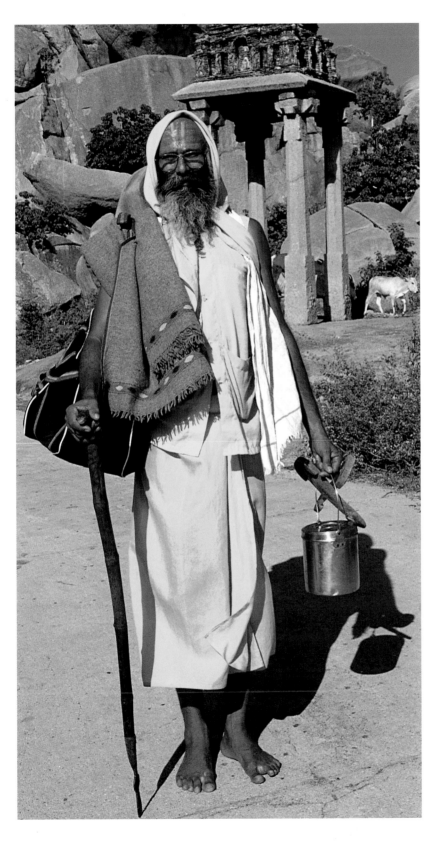

PREVIOUS PAGES
Women husking dried maize,
Kerala.

OPPOSITE
An atavistic shrine in the
remote hills of Karnataka.

LEFT
Holy man in Hampi
(Vijayanagara), Karnataka.

OVERLEAF
(LEFT) Nandi bull decorated
with turmeric. Madurai,
Tamil Nadu.

(RIGHT) Fetishist man
collecting alms in
Mahabalipuram
(Mamallapuram), Tamil
Nadu. He is covered in
turmeric powder.

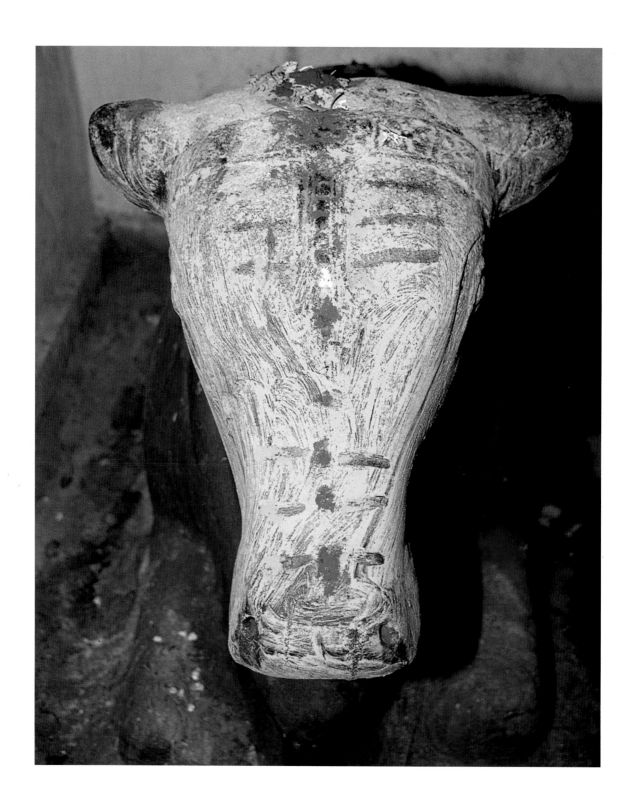

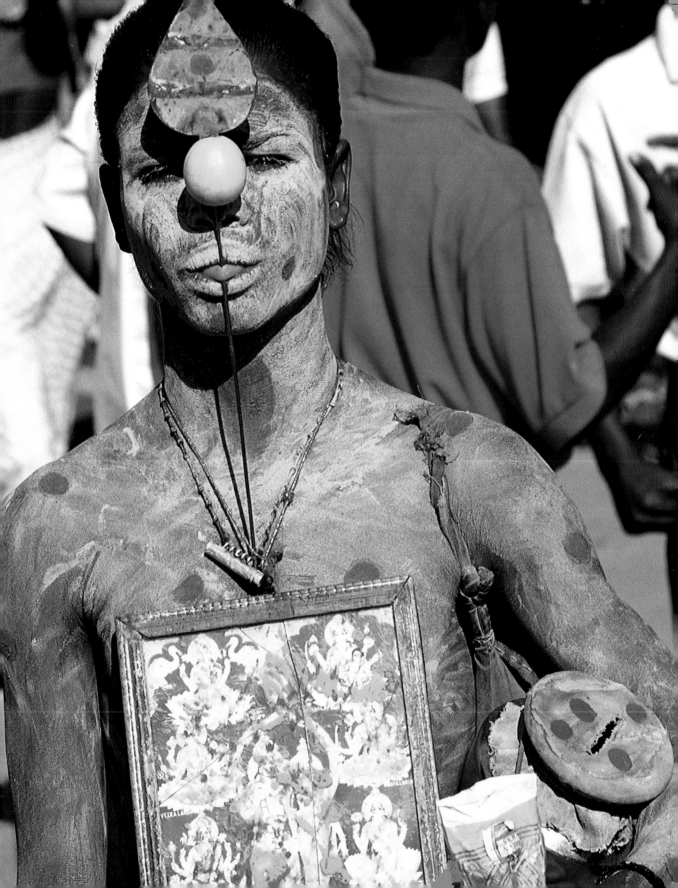

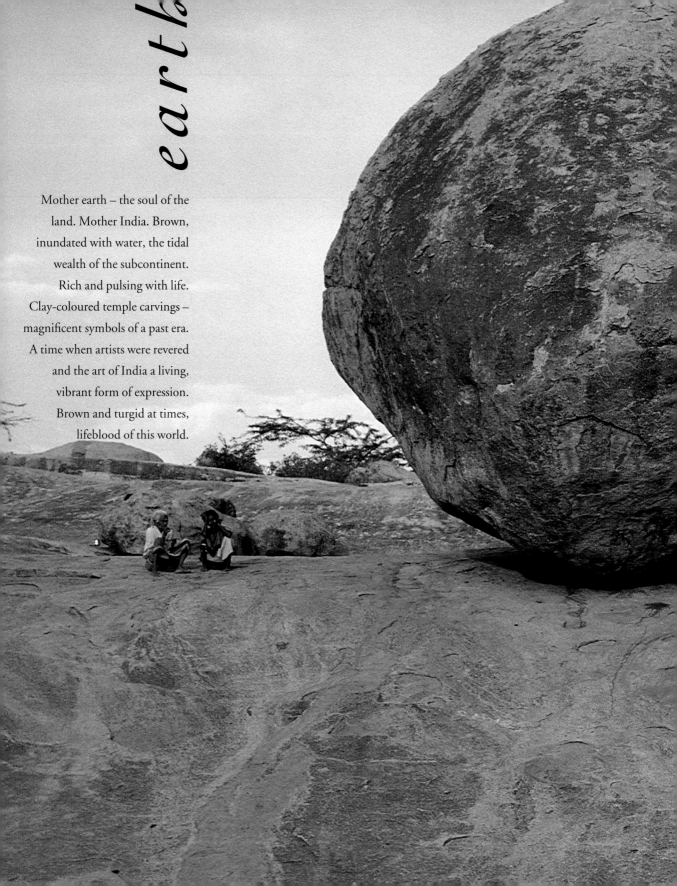

earth

Mother earth – the soul of the
land. Mother India. Brown,
inundated with water, the tidal
wealth of the subcontinent.
Rich and pulsing with life.
Clay-coloured temple carvings –
magnificent symbols of a past era.
A time when artists were revered
and the art of India a living,
vibrant form of expression.
Brown and turgid at times,
lifeblood of this world.

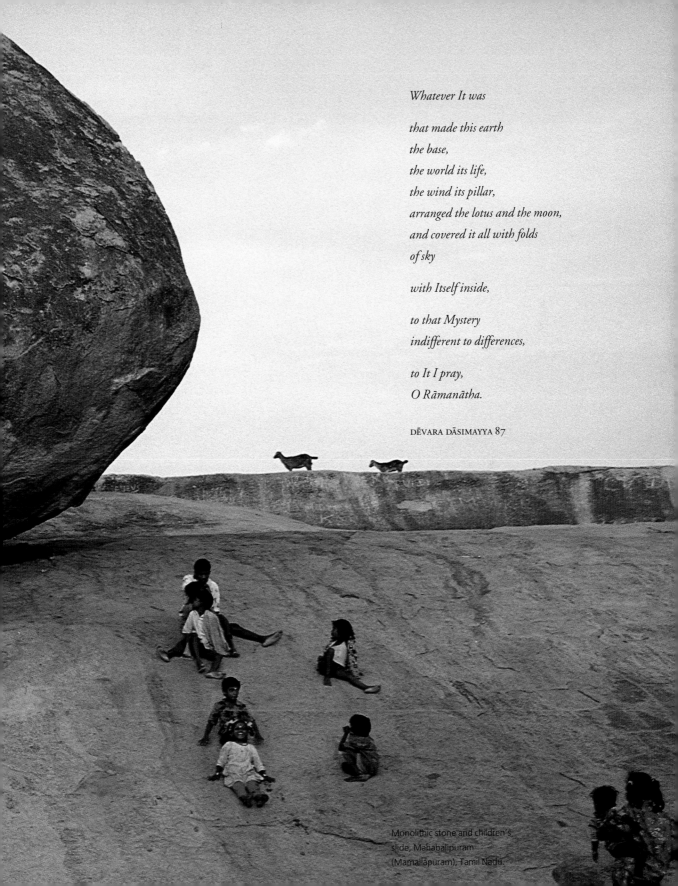

Whatever It was

that made this earth
the base,
the world its life,
the wind its pillar,
arranged the lotus and the moon,
and covered it all with folds
of sky

with Itself inside,

to that Mystery
indifferent to differences,

to It I pray,
O Rāmanātha.

DĒVARA DĀSIMAYYA 87

Monolithic stone and children's
slide, Mahabalipuram
(Mamallāpuram), Tamil Nadu.

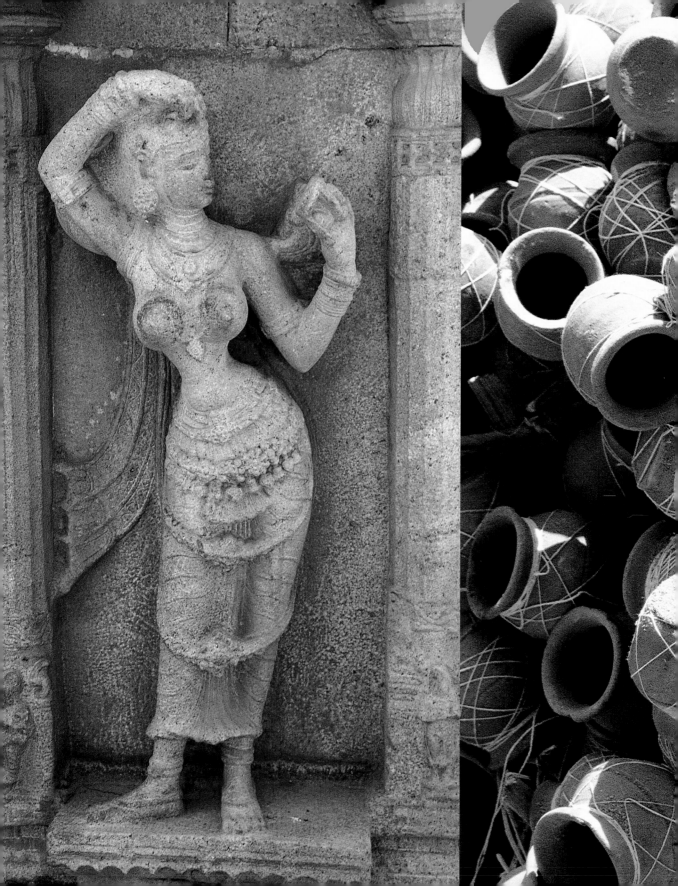

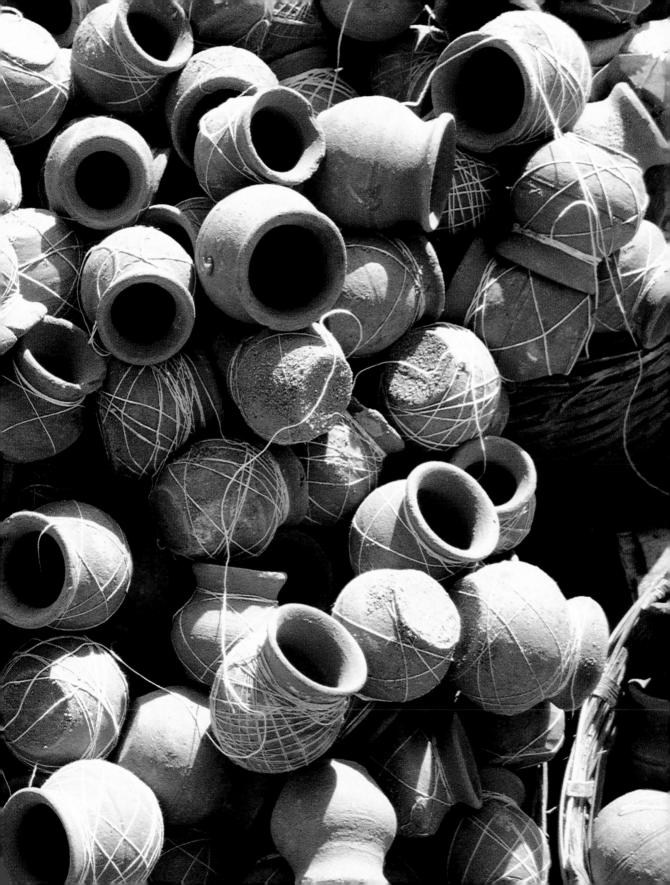

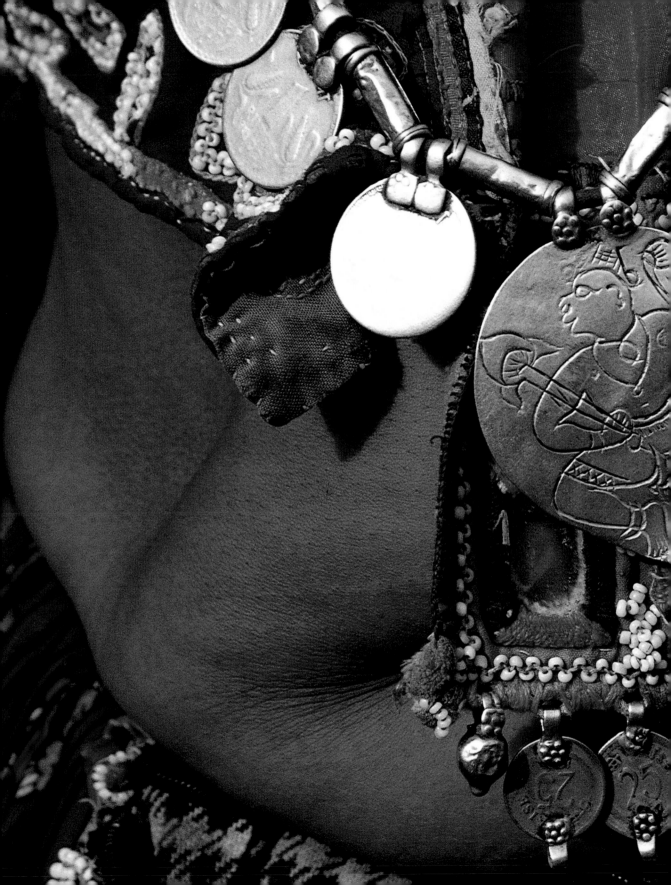

PREVIOUS PAGES
(LEFT) Ranganatha Temple,
Trichy (Tiruchchirappalli) in
Tamil Nadu. A beautiful
carving of a woman placing
a *tikka* on her forehead. This
carving is of the Chola period
and dates from between the
13th and 17th centuries.

(RIGHT) Clay *puja* pots,
after a single use,
lie discarded in a pile.

LEFT
Detail of the jewelry worn
by elderly Lombardi (tribal)
women. In this case, they are
coins and an engraving of
the monkey-god Hanuman.

OVERLEAF
(LEFT) A Brahmin priest,
his skin cracked with age,
reading.

(RIGHT) Coir rope in the
market.

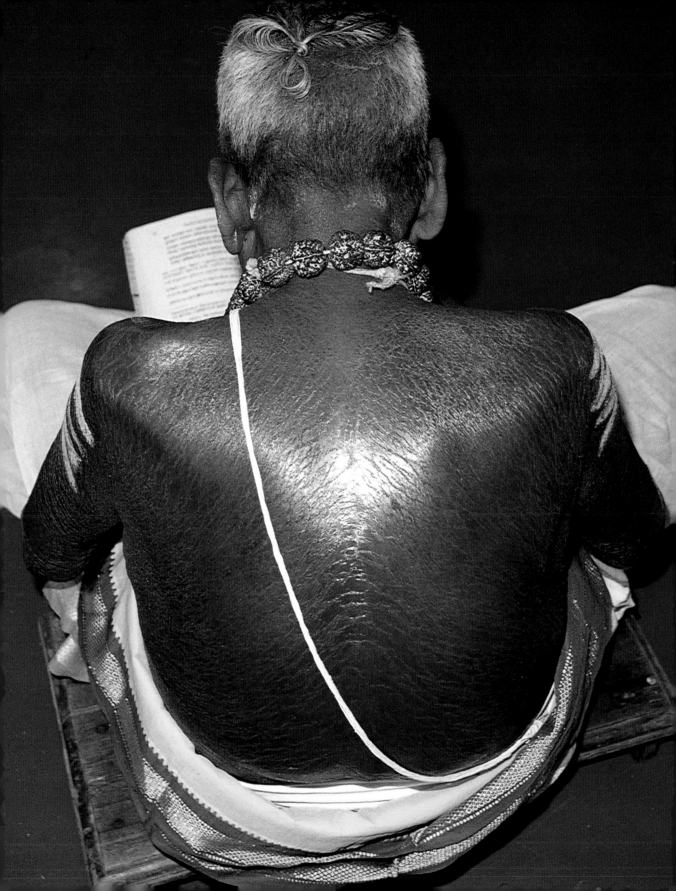

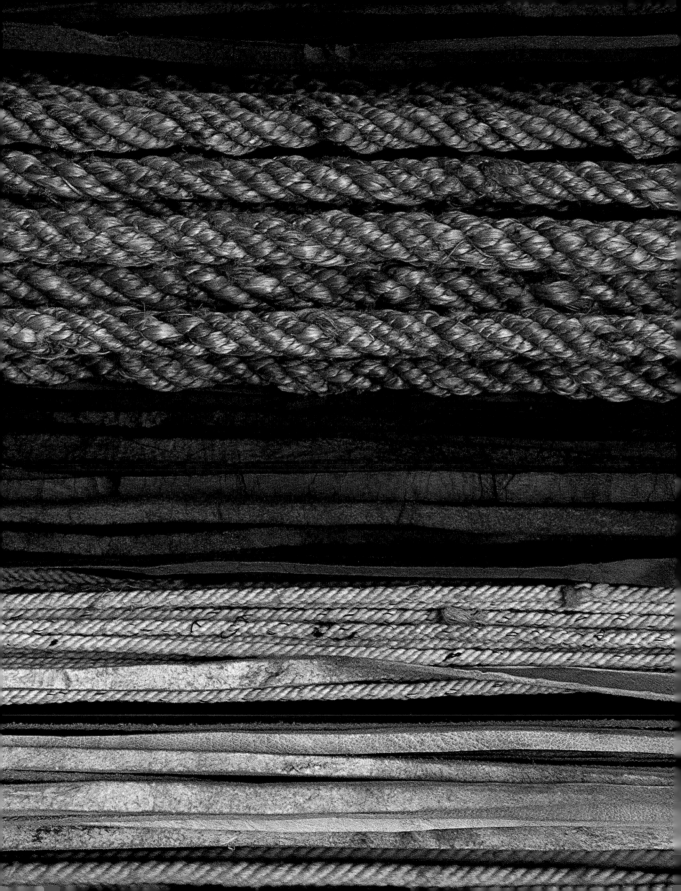

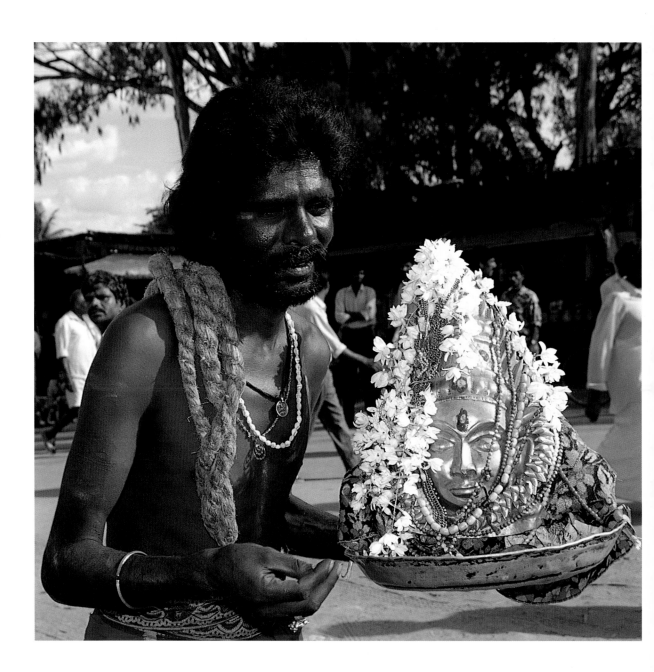

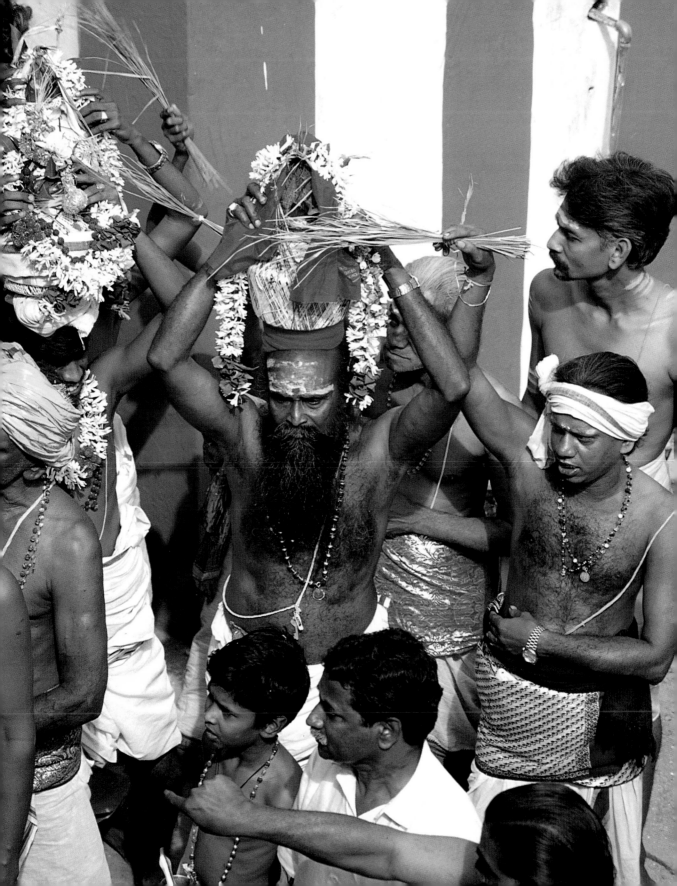

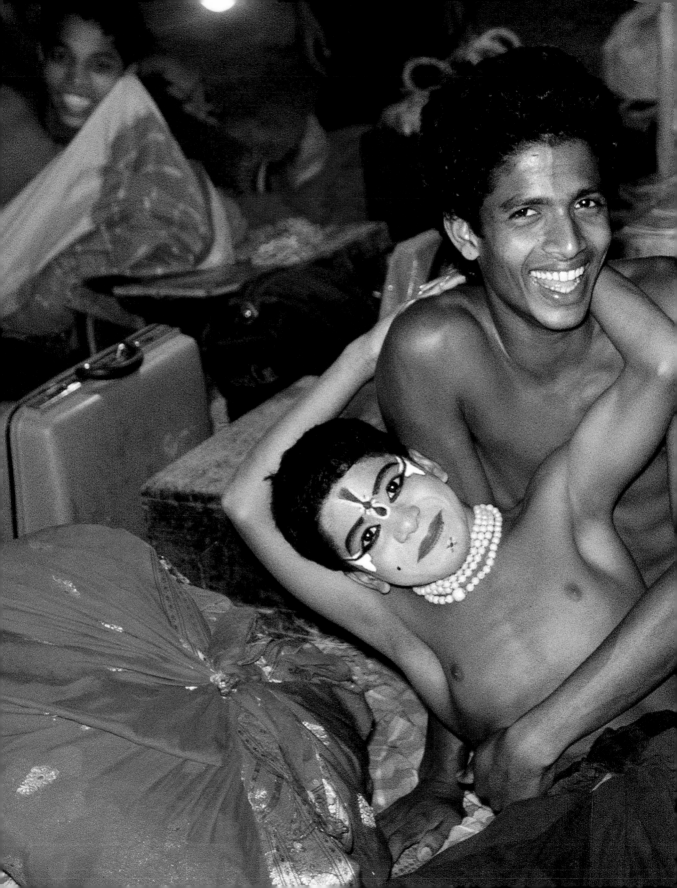

PREVIOUS PAGES
(LEFT) This man is a dervish.
A follower of the goddess Kali,
he flagellates himself with the
rope he is wearing.

(RIGHT) A temple in Madras
(Chennai), Tamil Nadu, has
re-opened and the temple
priests circulate around the
walls offering blessings.

LEFT
Yakshagana (celestial
chanting) dancers at rest
before their night-long
performance, Karnataka.

OVERLEAF
(LEFT) Fish drying in the sun,
Tamil Nadu.

(RIGHT) Jain carvings near
the monolithic temple at
Kalugumalai, Tamil Nadu
(c. 8th century AD).

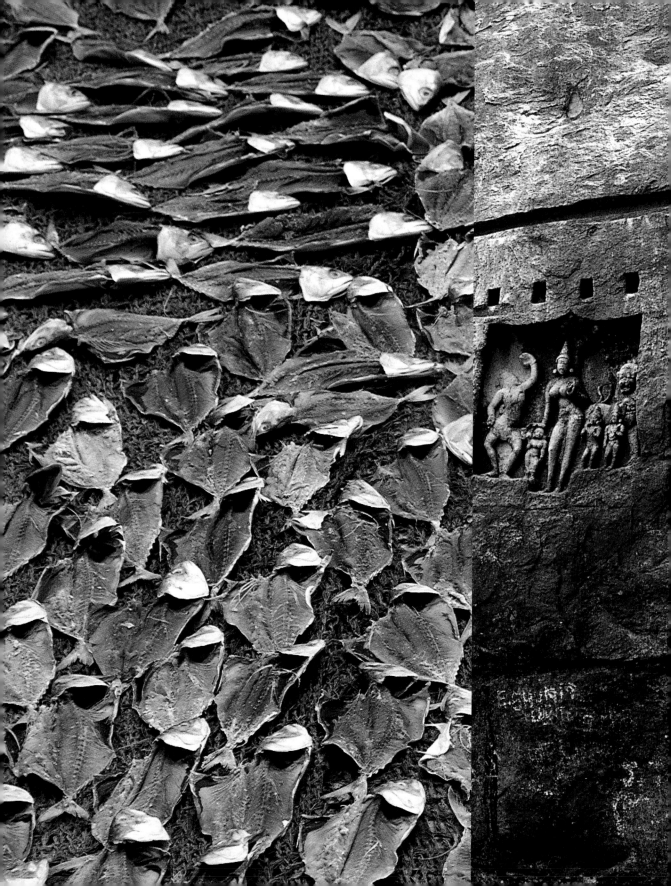

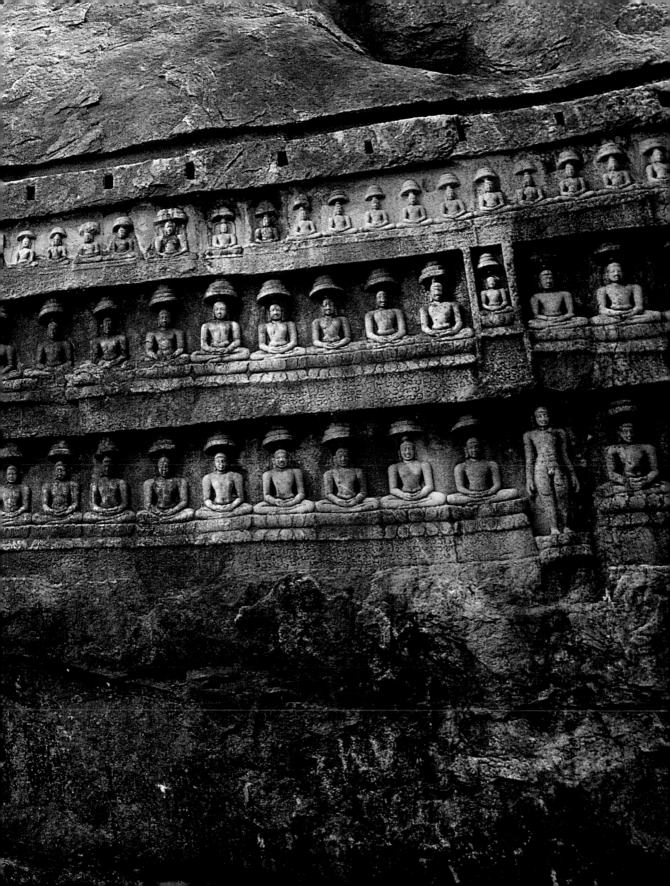

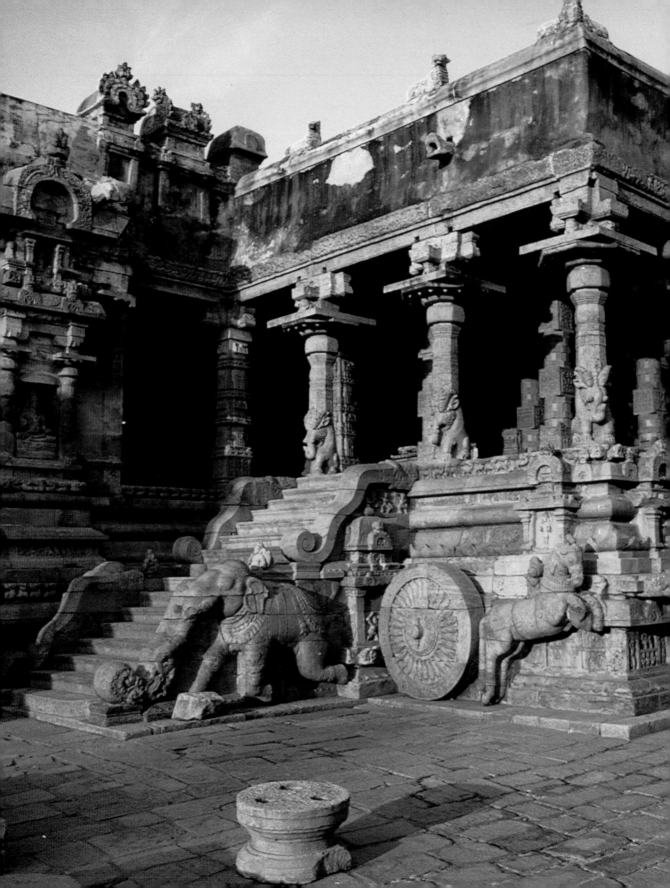

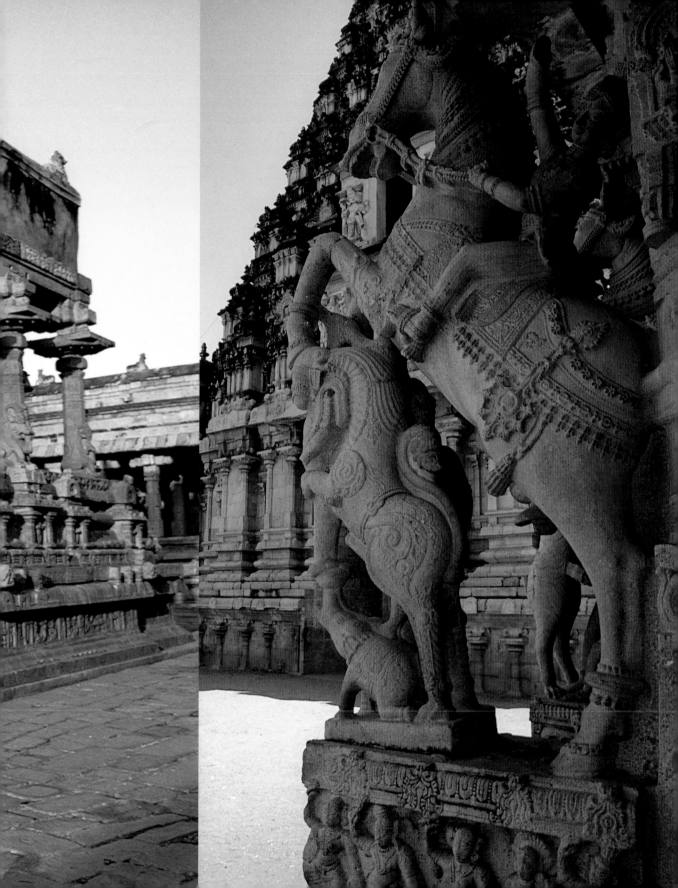

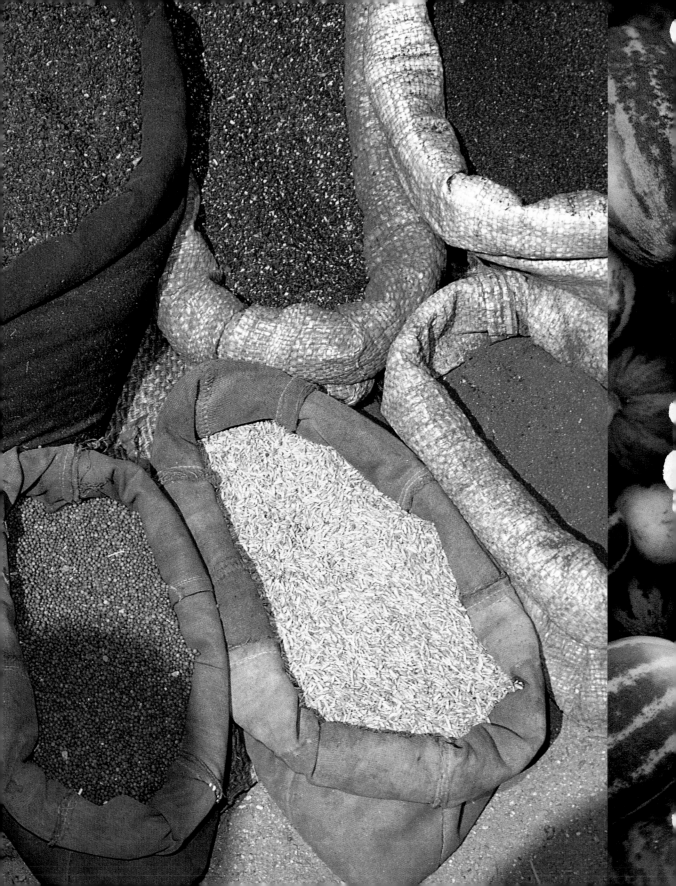

A variety of gourds.

PREVIOUS PAGES
(LEFT) Brihadishvara Temple,
Thanjavur, Tamil Nadu.
A magnificent construction
of the Chola period
(early 11th century).

(RIGHT) Detail of temple
sculpture: a beautiful carved
warrior on horseback.

OPPOSITE
Pulses and grains in the
market.

LEFT
A variety of gourds.

OVERLEAF
1 Two of the monolithic
Pancha Ratha temples
at Mahabalipuram
(Mamallapuram), Tamil Nadu.

2 Entrance to a Muslim
tomb, northern Karnataka.

3 Side view of the beautiful
monolithic carving, Arjuna's
Penance, at Mahabalipuram
(Mamallapuram), Tamil Nadu.
This is said to be one of the
earliest carved works in
Southern India.

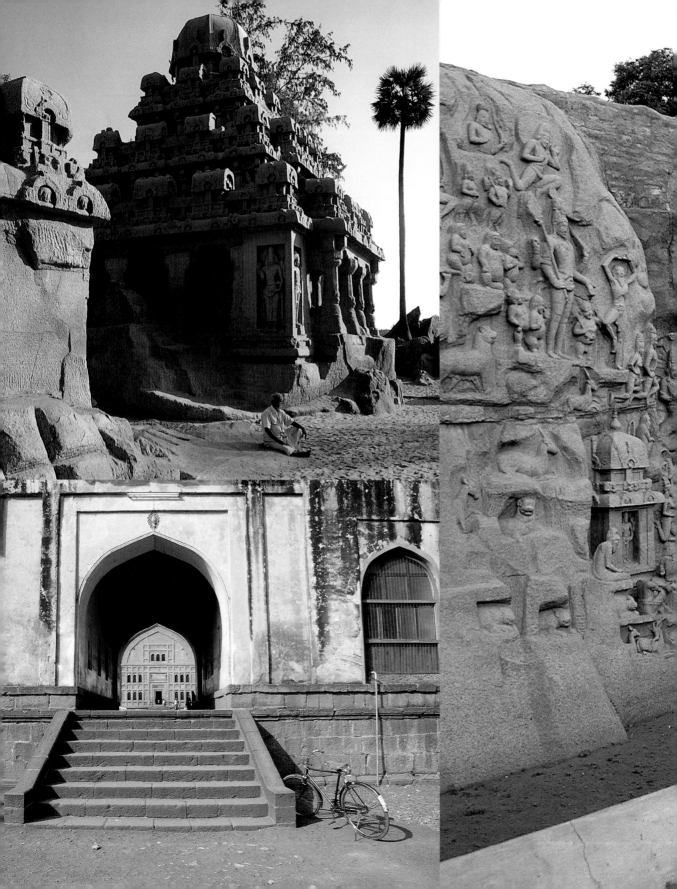

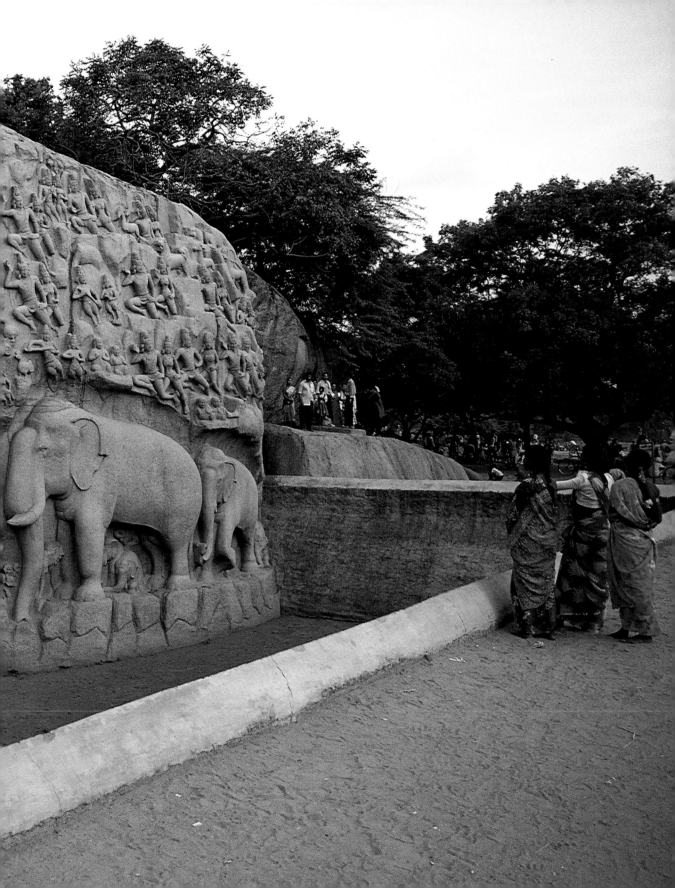

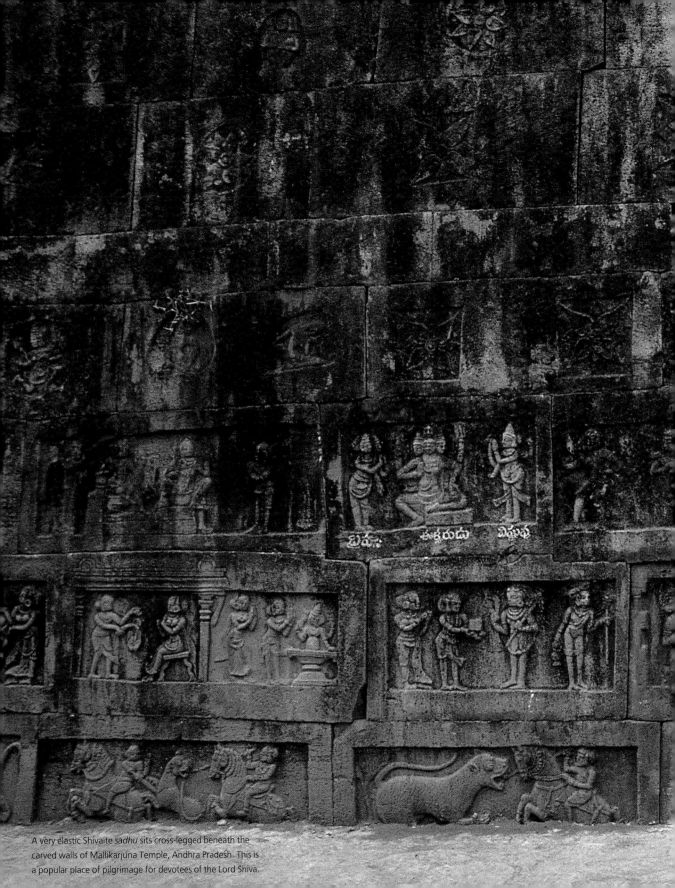

 బ్రహ్మ ఈశ్వరుడు విష్ణువ

A very elastic Shivaite *sadhu* sits cross-legged beneath the carved walls of Mallikarjuna Temple, Andhra Pradesh. This is a popular place of pilgrimage for devotees of the Lord Shiva.

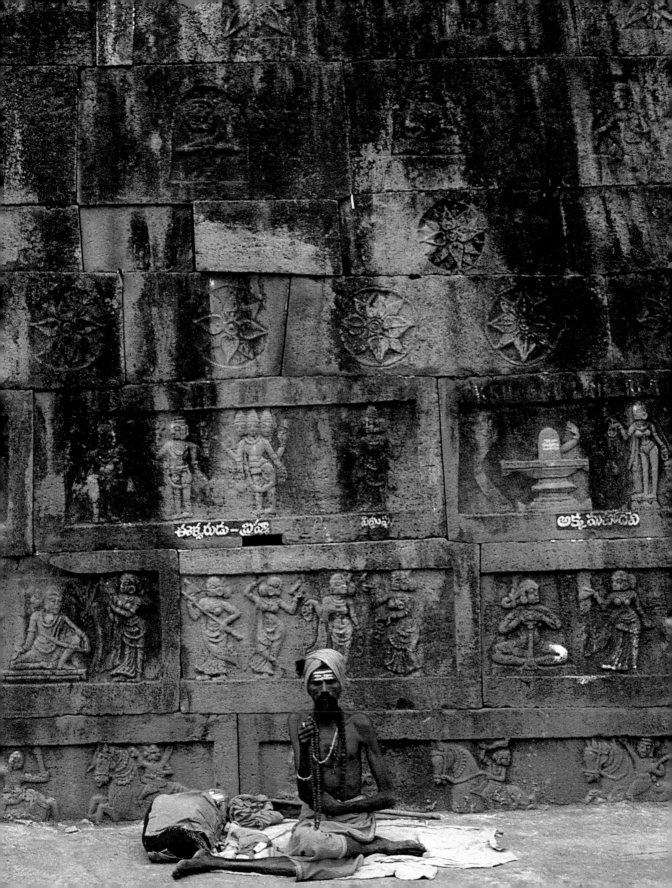

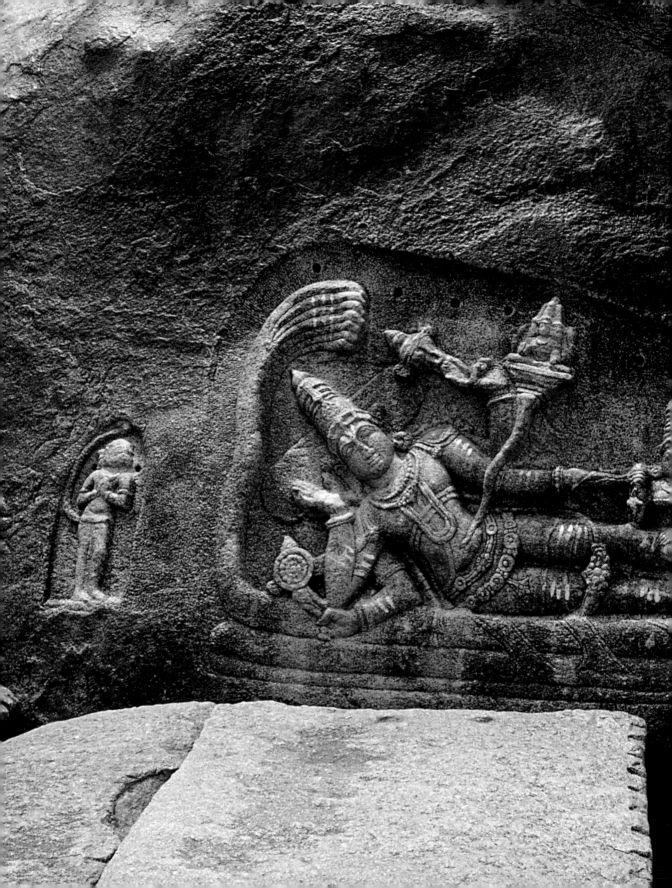

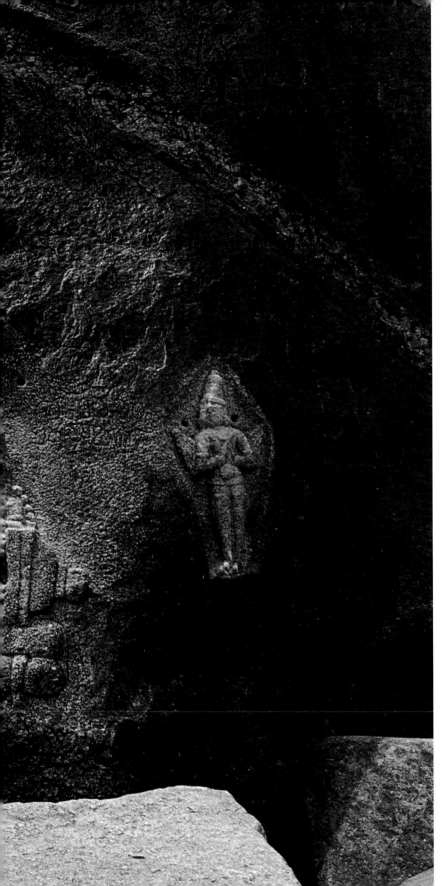

black

Night. Evil spirits and thoughts
rise to the fore. Meditation
and passive contemplation.
An end to the day – a small
death. Granite temple carvings.
Small windows in the dark.
Fire gives the soul a hope
for tomorrow.

O swarm of bees
O mango tree
O moonlight
O koilbird
I beg of you all
one
favour:

> *If you should see my lord anywhere*
> *my lord white as jasmine*

call out
and show him to me.

MAHĀDĒVIYAKKA 74

LEFT
A carving of Ananta-
shayana hidden
amongst the boulders
near the river at Hampi
(Vijayanagara), Karnataka.

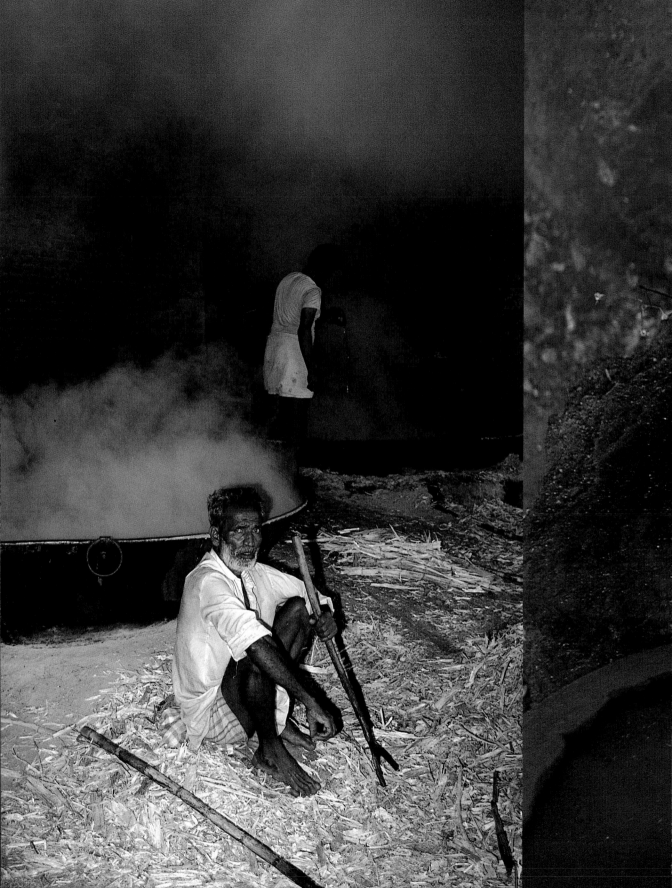

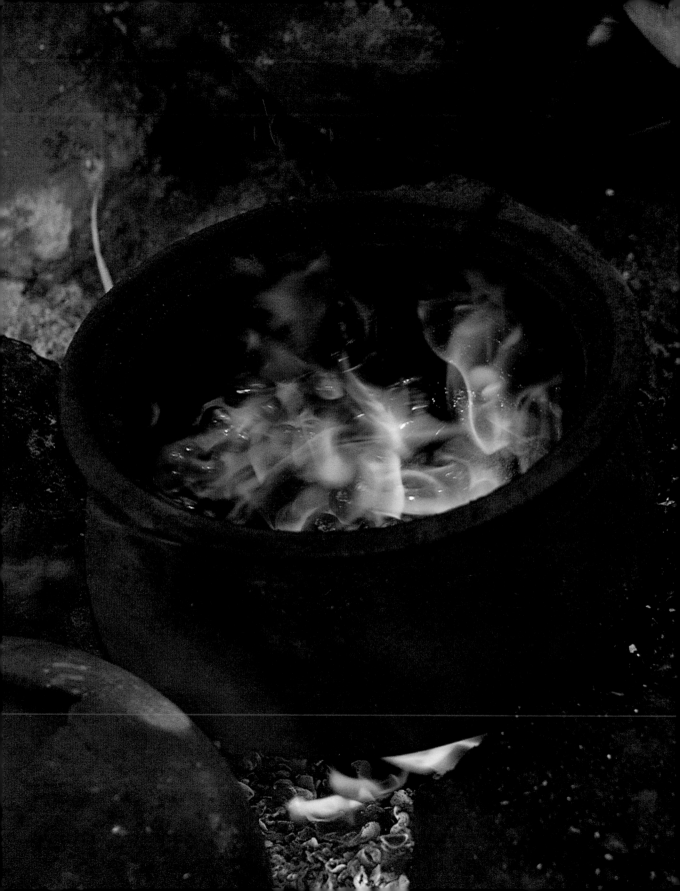

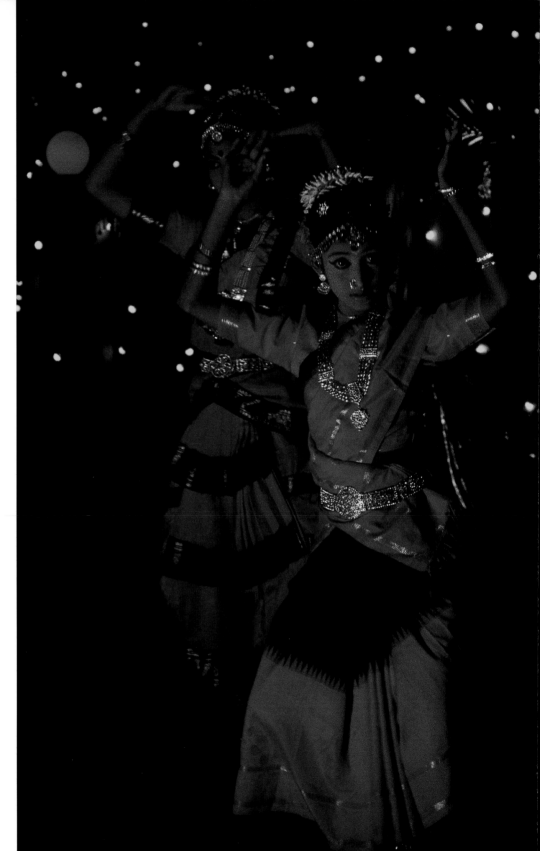

PREVIOUS PAGES

(LEFT) Man cooking jaggery.

(RIGHT) Cashew nuts being cooked by the roadside.

RIGHT

Child dancing *Bharat nataji*, a form of dance unique to Tamil Nadu.

OPPOSITE

A temple goddess is reverentially dressed and made up by the Brahmin priest in preparation for the temple festival.

OVERLEAF

The colonnaded passage at Hoysaleshvara Temple (early 12th century), Halebid, Karnataka. This is one of the most beautiful examples of Hoysola creativity.

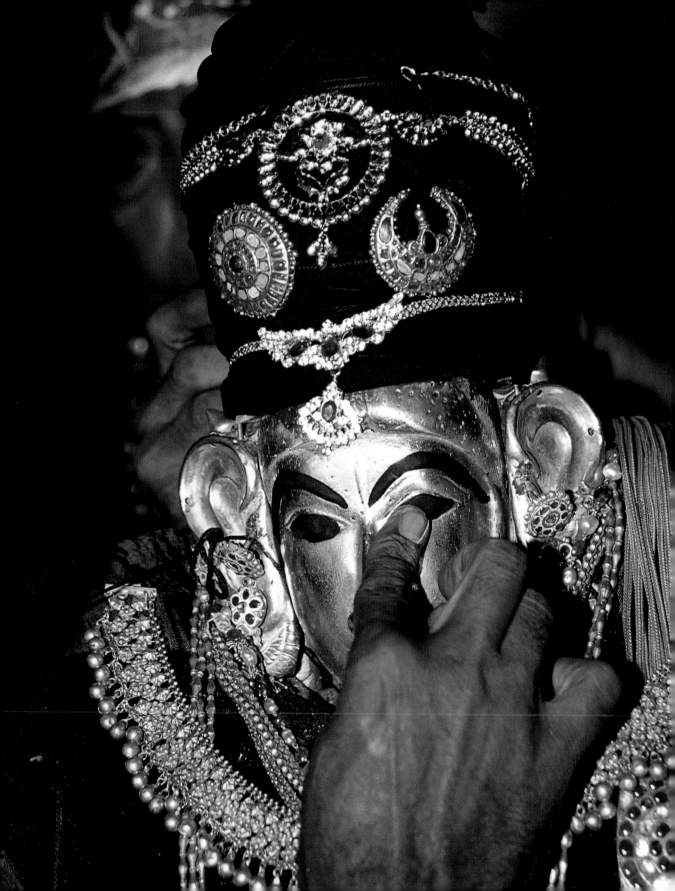

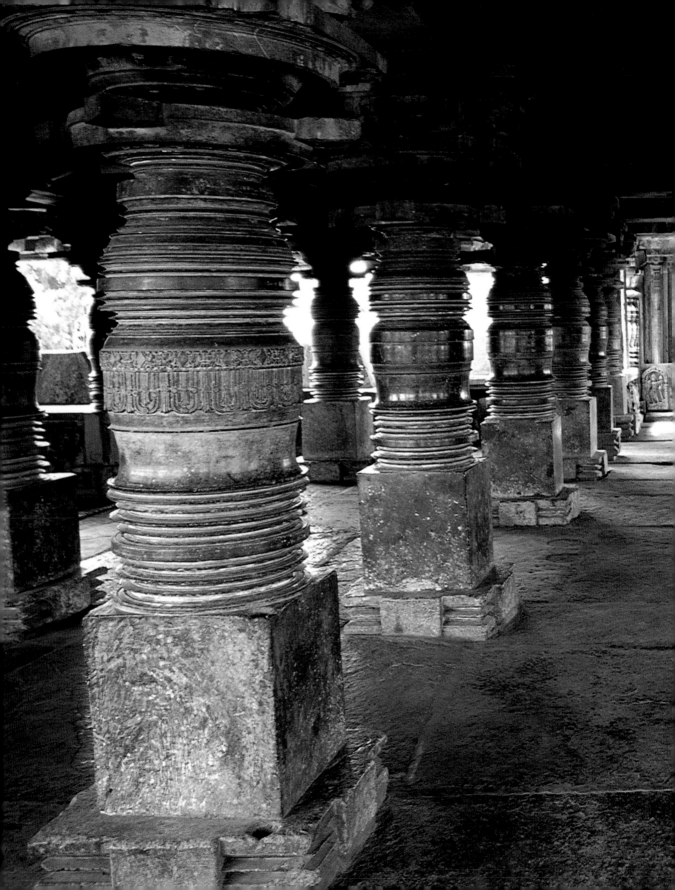

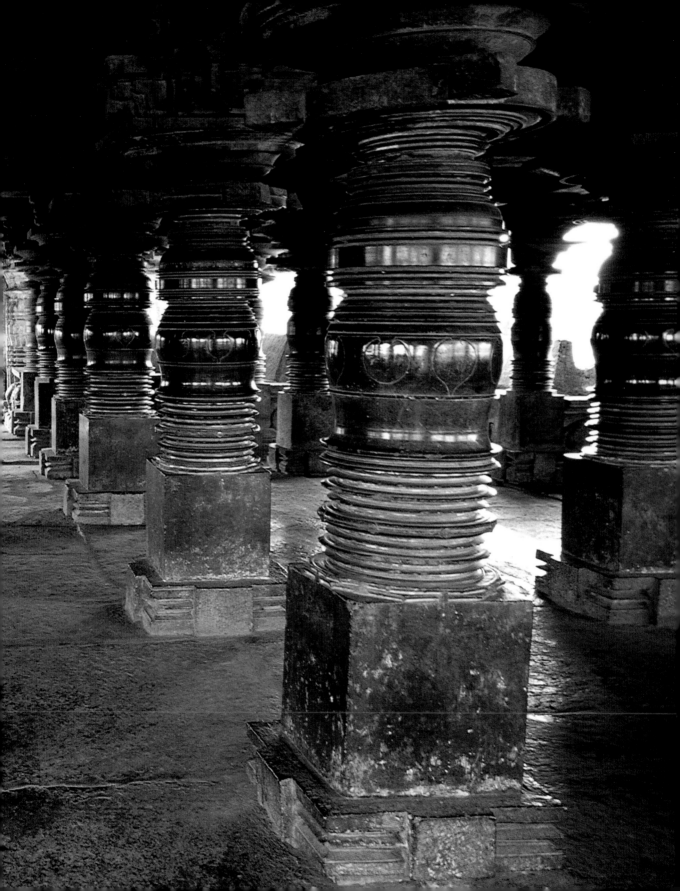

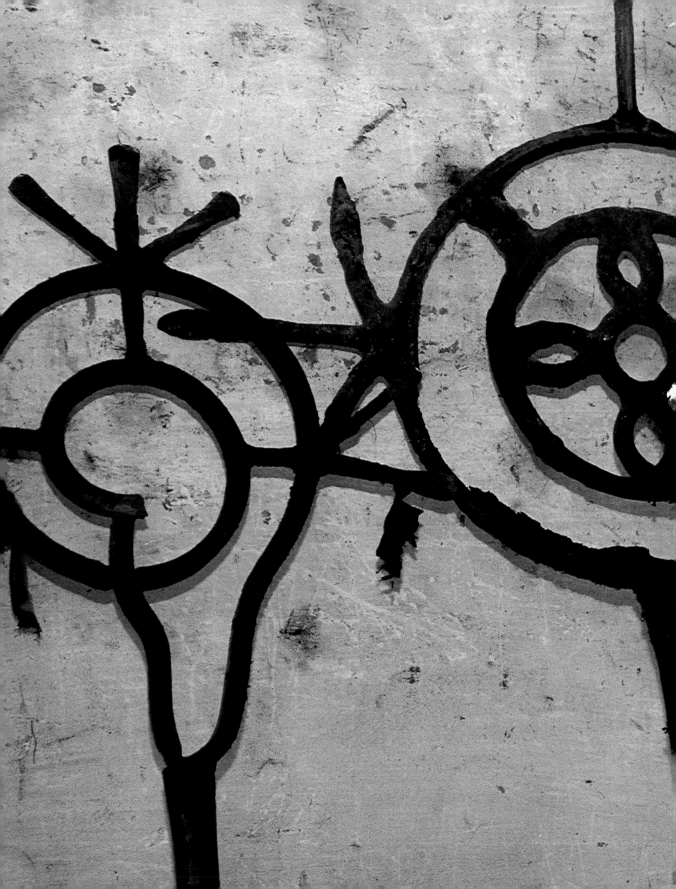

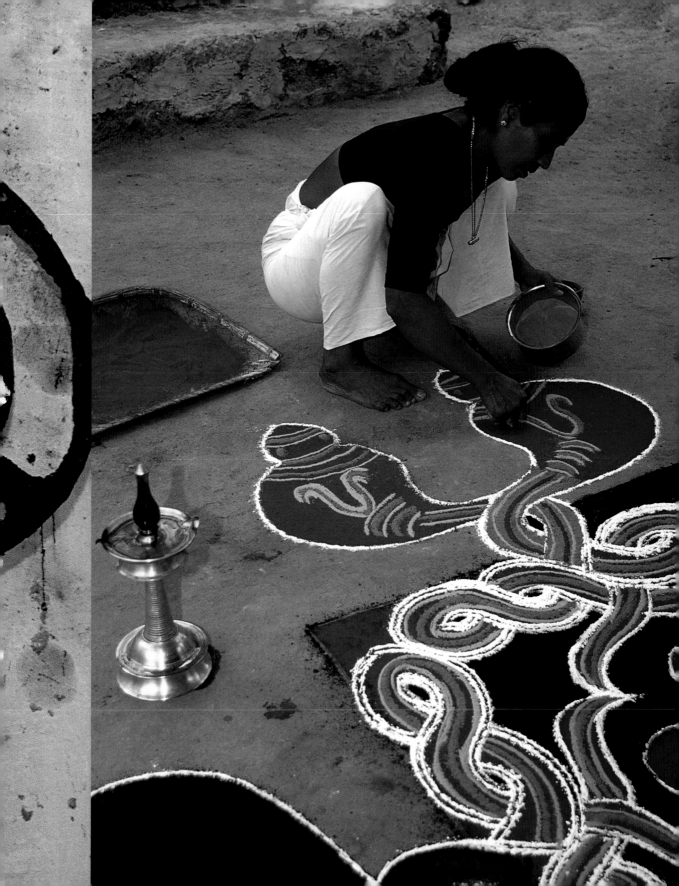

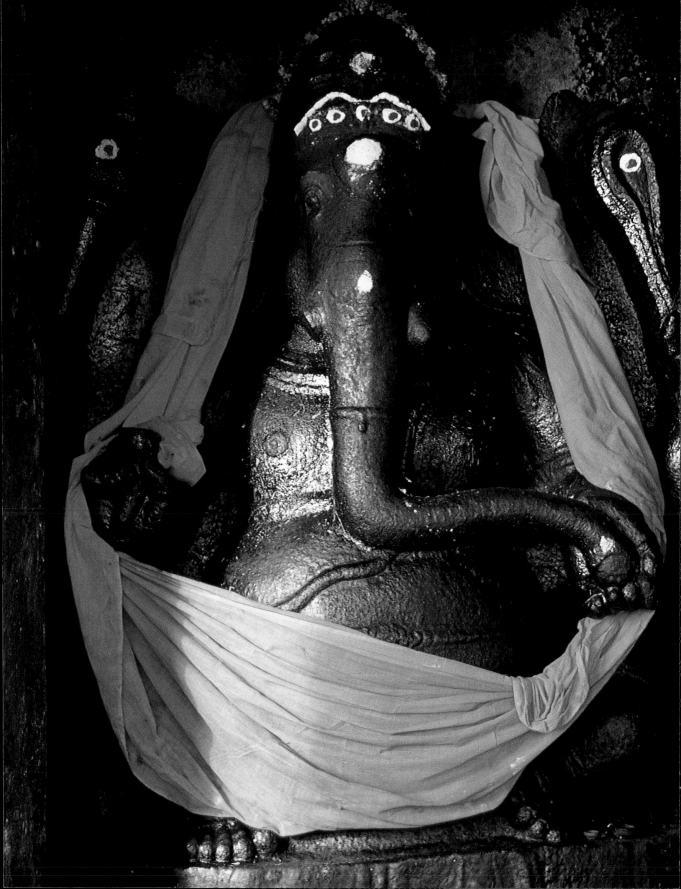

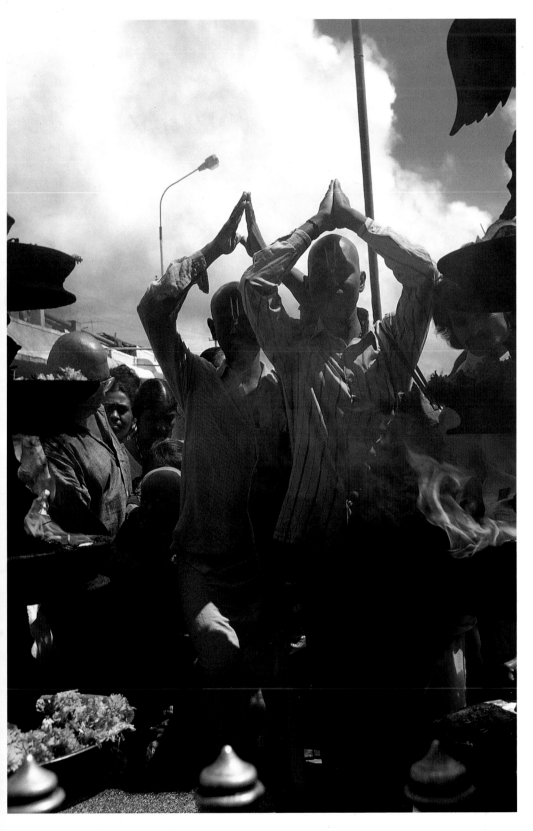

PREVIOUS PAGES
(LEFT) Flares for a temple festival.

(RIGHT) The matriarch of the Pullava sect, who are a dying breed that produces snake-shaped *pambin kalam* designs for special occasions.

OPPOSITE
The elephant-headed god Ganesh draped in a beautiful red cloth.

LEFT
Pilgrims at prayer outside the Holy Temple at Tirumala, Andhra Pradesh.

OVERLEAF
Detail of a Nandi bull decorated with petals and *dum dum* powder.

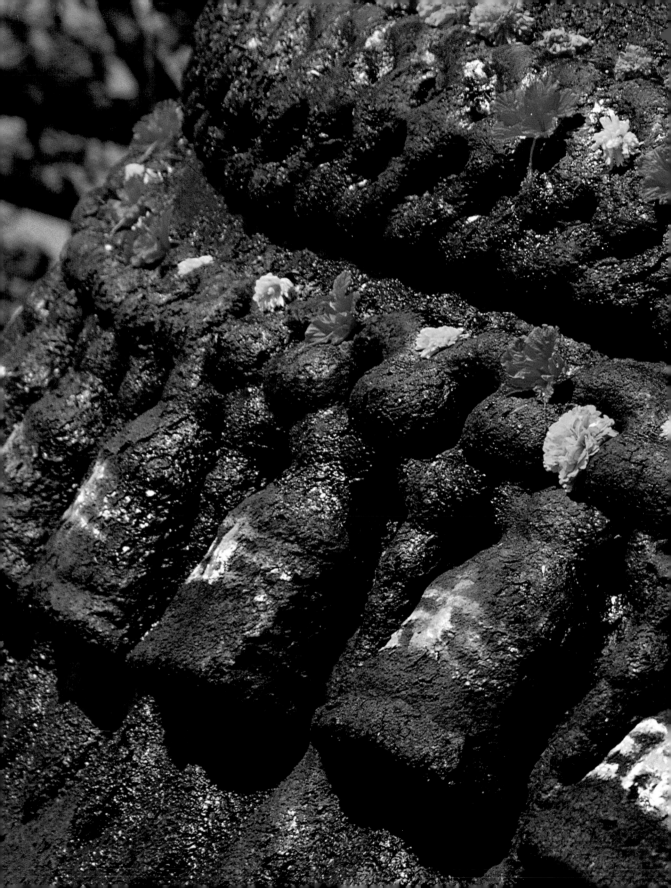

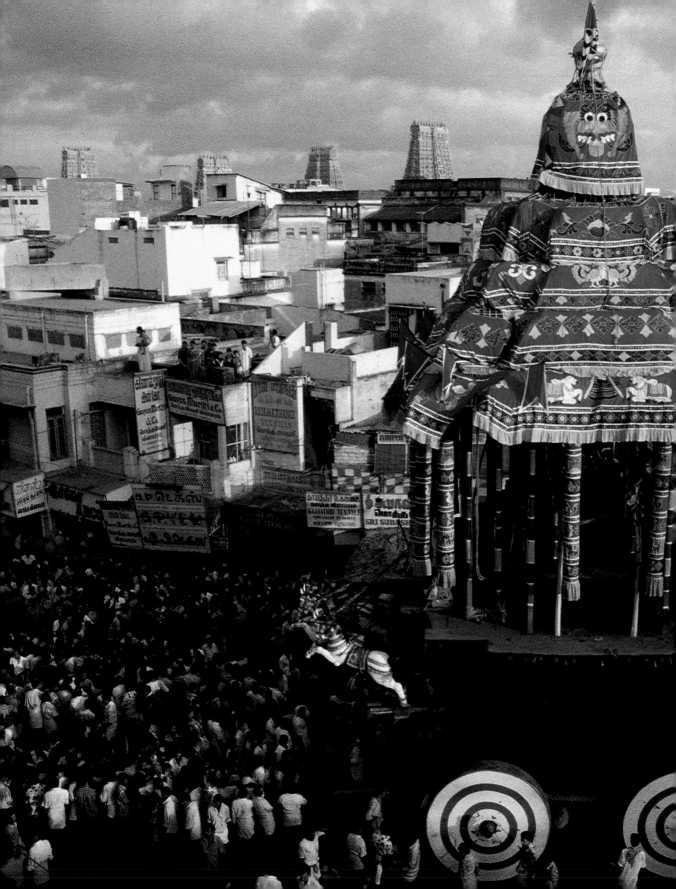

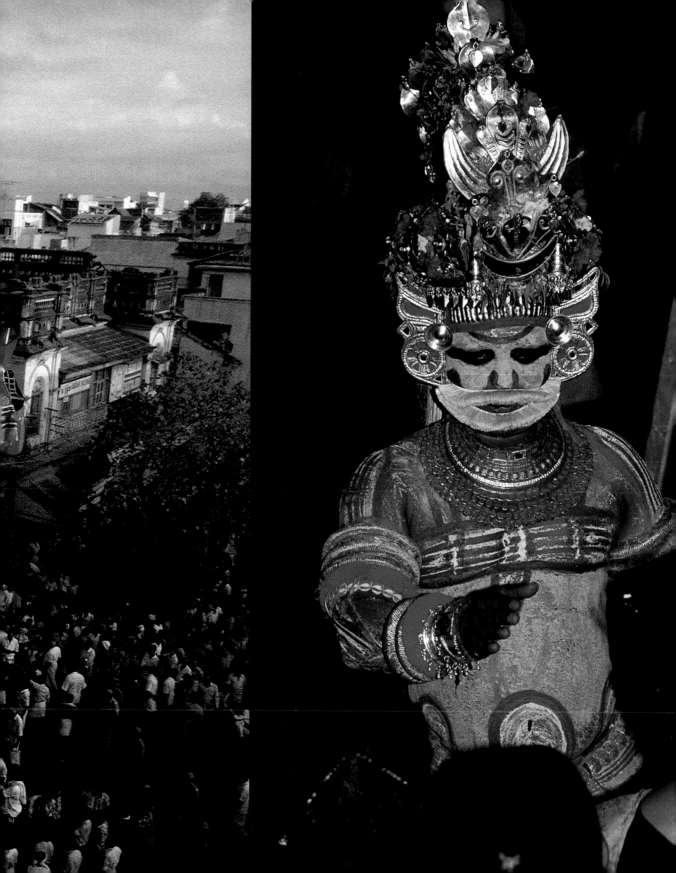

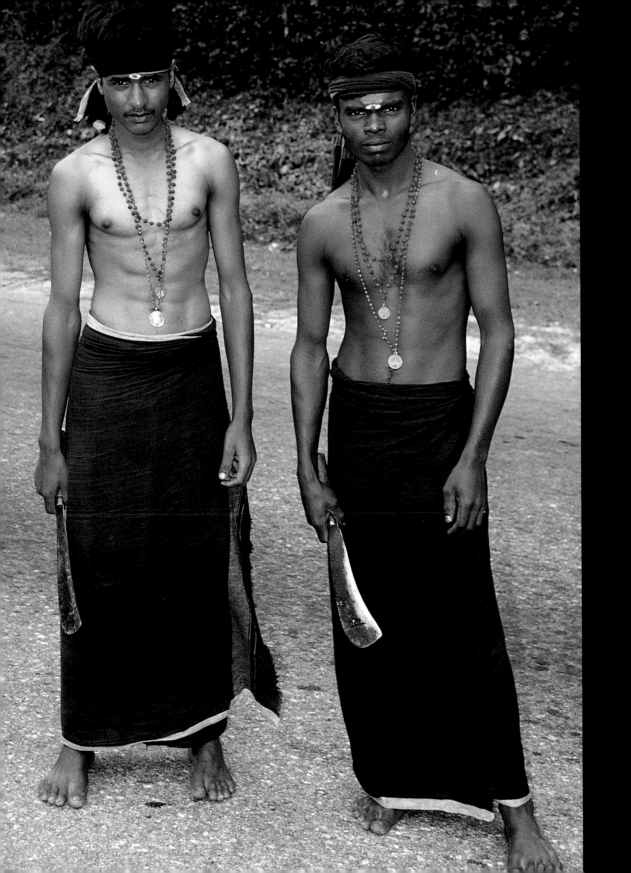

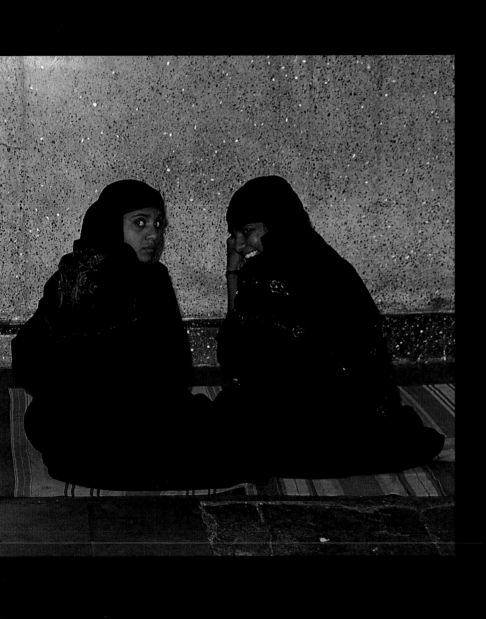

PREVIOUS PAGES
(LEFT) The Chariot Festival
in Madurai, Tamil Nadu,
where the holy edifice is
dragged on wheels around
the city limits by willing
worshippers.

(RIGHT) A unique dance in a
remote temple in Karnataka
performed by the Brahmin
priest. Strangely, this
ceremony ends with him
drinking toddy (fermented
palm juice).

OPPOSITE
These two boys are pilgrims
and followers of a guru who
lives many miles away. They
will walk barefoot for weeks
to reach his hermitage,
wearing these traditional
black clothes and beads.

LEFT
Muslim girls at prayer
outside the mosque walls
in Bijapur, Karnataka.

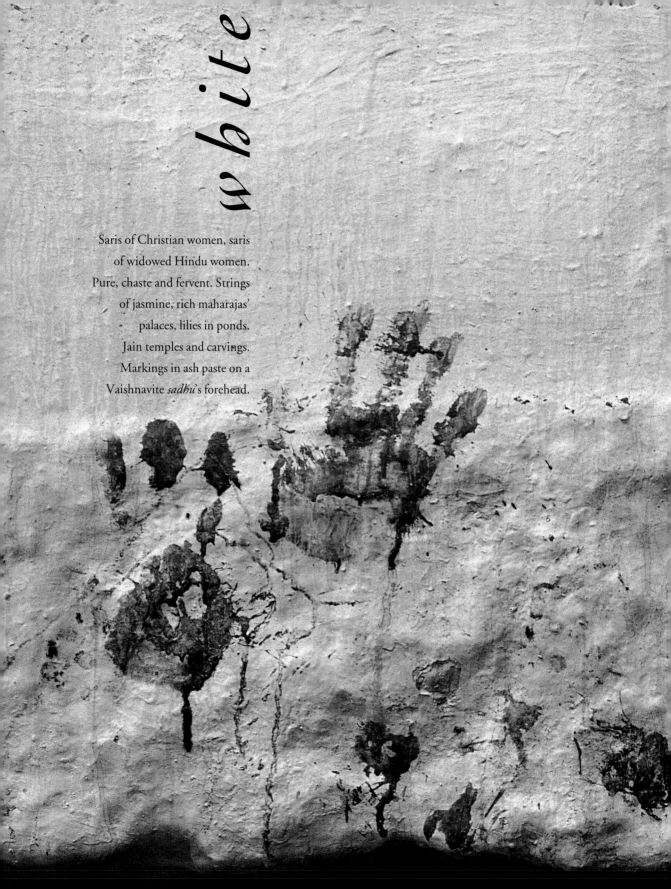

white

Saris of Christian women, saris
of widowed Hindu women.
Pure, chaste and fervent. Strings
of jasmine, rich maharajas'
palaces, lilies in ponds.
Jain temples and carvings.
Markings in ash paste on a
Vaishnavite *sadhu*'s forehead.

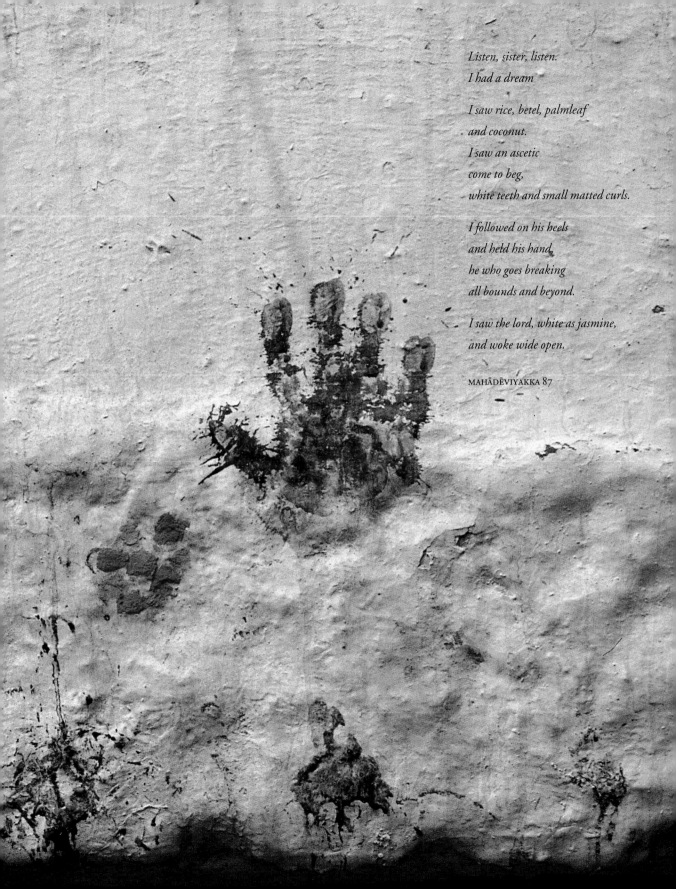

Listen, sister, listen.
I had a dream

I saw rice, betel, palmleaf
and coconut.
I saw an ascetic
come to beg,
white teeth and small matted curls.

I followed on his heels
and held his hand,
he who goes breaking
all bounds and beyond.

I saw the lord, white as jasmine,
and woke wide open.

MAHĀDĒVIYAKKA 87

PREVIOUS PAGES
These hand prints were
made by women about
to commit *sati* (or suttee:
self-immolation) on their
husbands' funeral pyres.
Although the practice
is outlawed today, old
prints are preserved in this
way in remote areas.

RIGHT
Christian worshippers gather
outside a cathedral in Kerala
after Sunday prayers.

OPPOSITE
This girl is attending
communion in a Christian
church in Kerala. The
Christian women wear
specially adapted white
saris to attend services.

OVERLEAF
(LEFT) Chalk sticks.

(RIGHT) Detail of the foot
of the giant Gommateshvara
monolith, Sravana Belgola,
Karnataka (a celebrated Jain
pilgrimage town). At the top
of a climb of 145 metres
(475 feet) up steps cut
into the rock, this huge
figure dominates a
beautiful landscape and
is greatly revered.

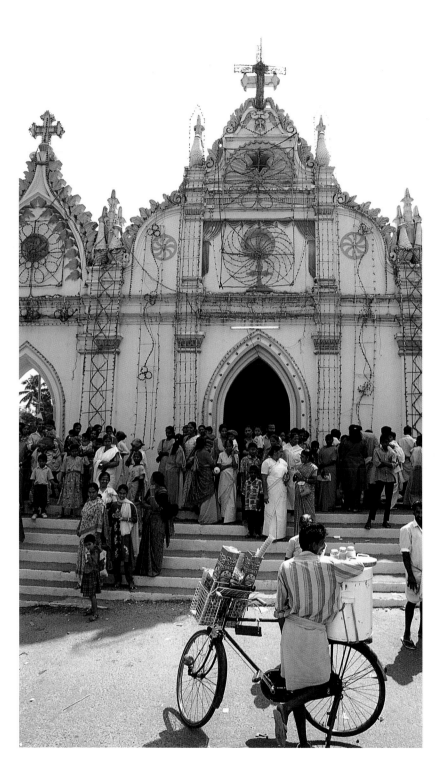

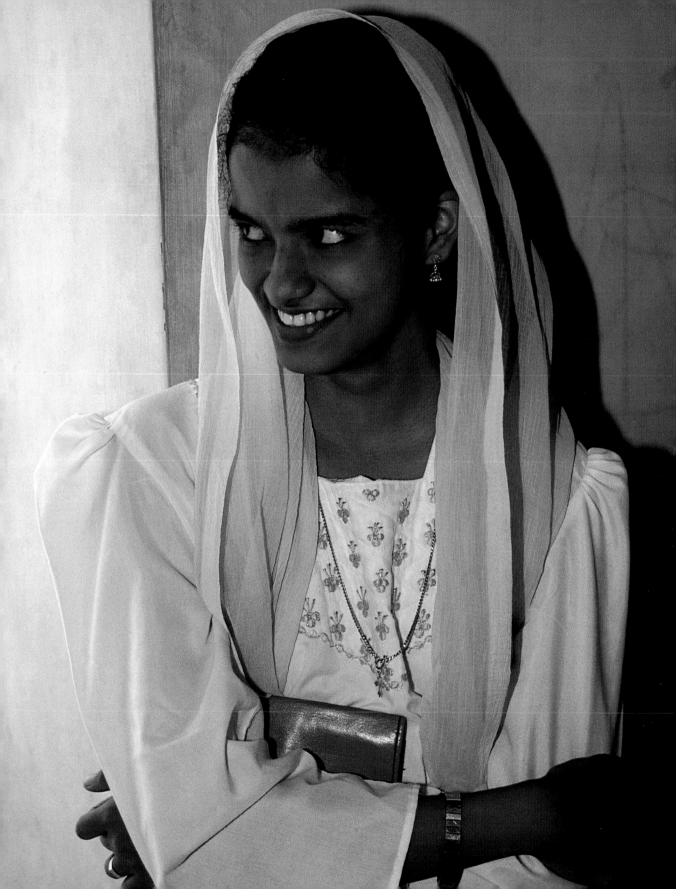

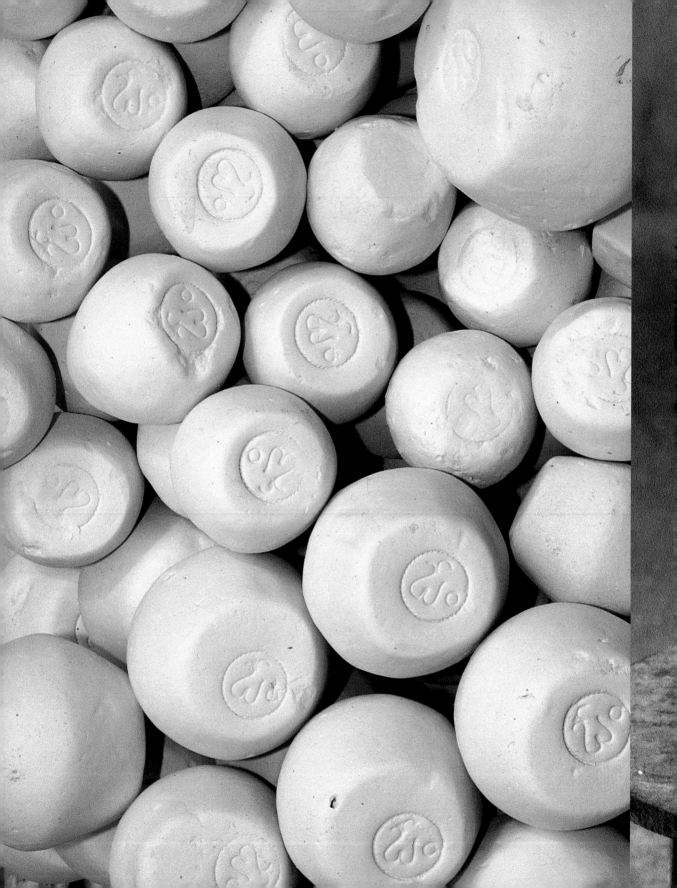

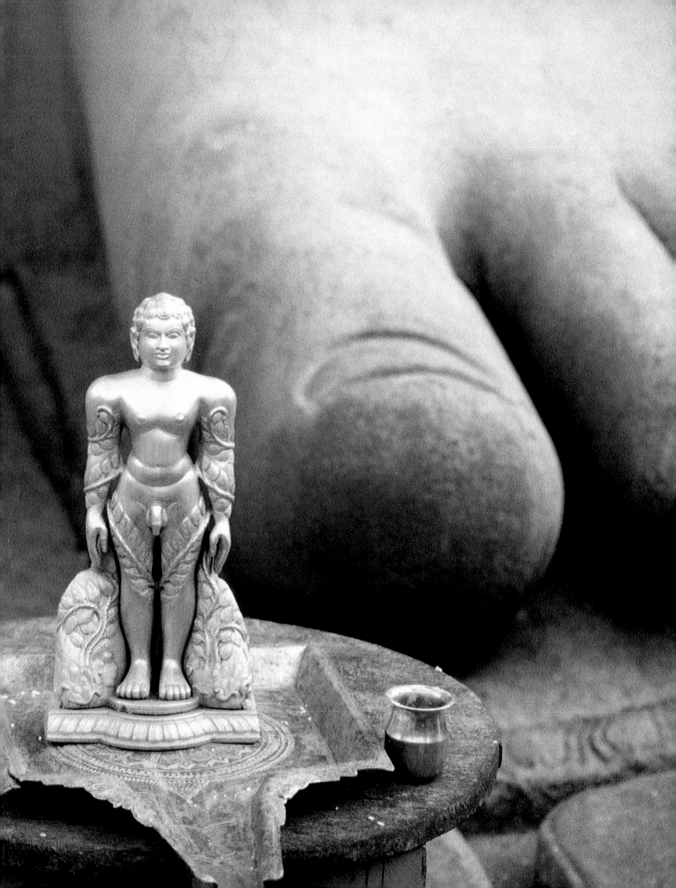

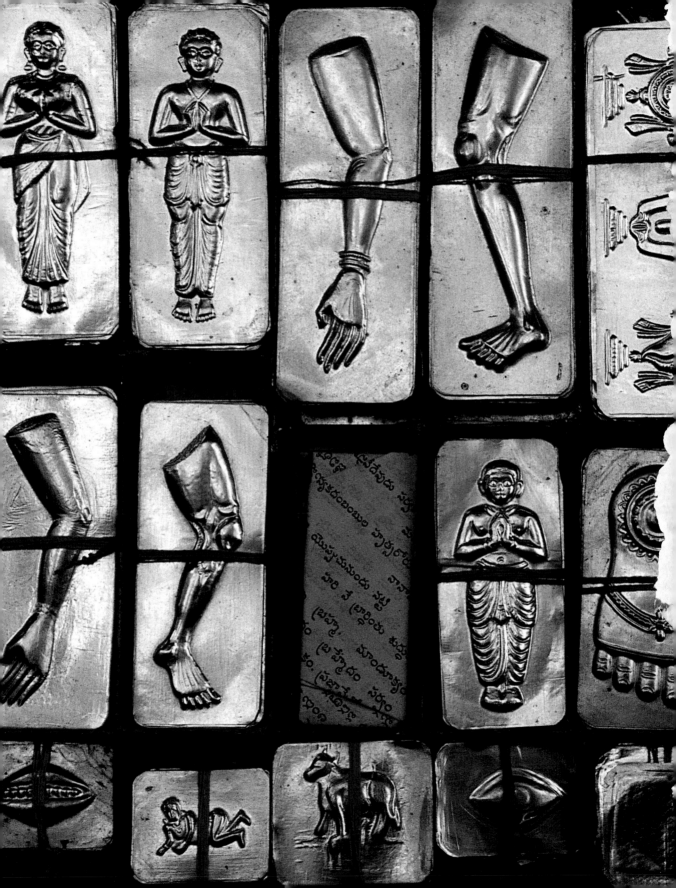

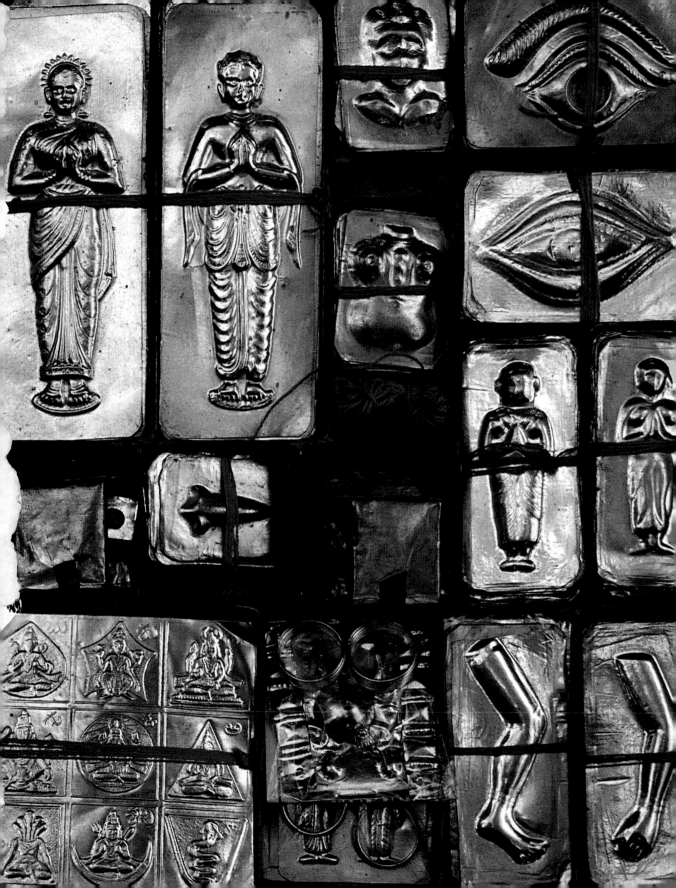

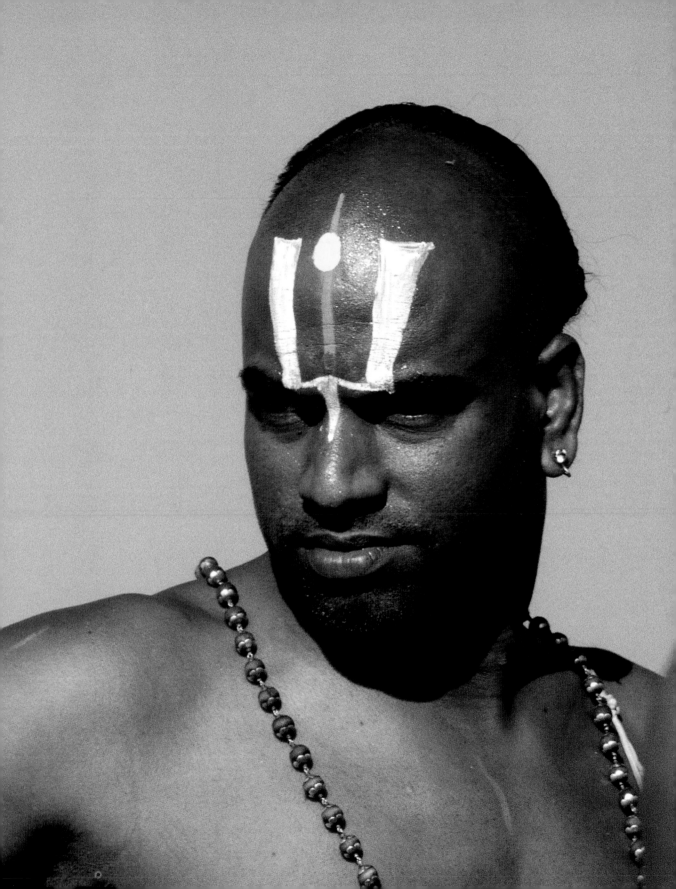

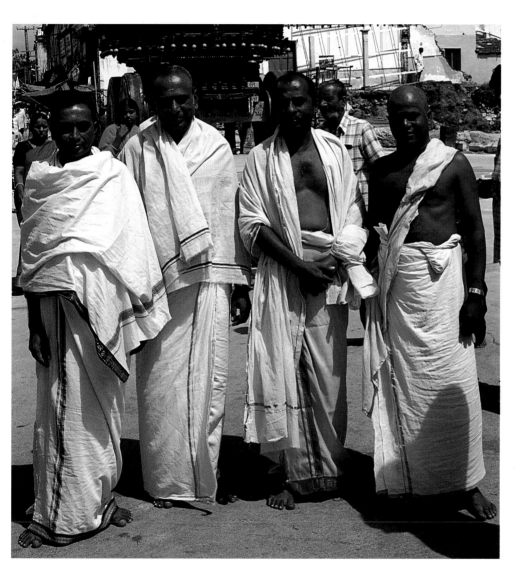

PREVIOUS PAGES
These silver talismans are for
sale outside Hindu temples.
Worshippers buy the symbol
of their wish and present it to
the god in the temple to assist
in its fulfilment.

OPPOSITE
A Brahmin priest of
the Vaishnavite sect.

LEFT
Pilgrims at Tirumala Temple,
near Tirupati, Andhra Pradesh.
One of India's most cherished
Hindu worshipping places,
it is visited by millions of
pilgrims annually.

OVERLEAF
Mosque detail in Tadpatri,
Andhra Pradesh.

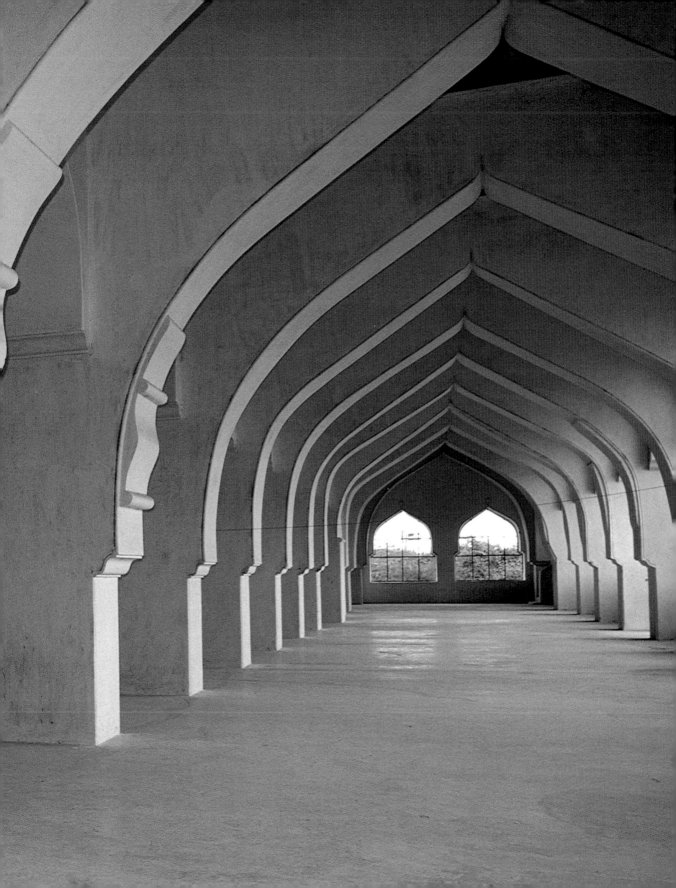

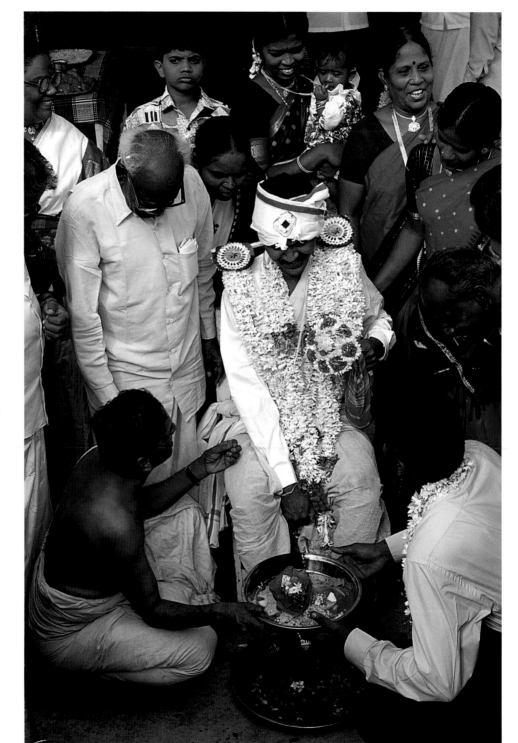

RIGHT
This young man has just got married. He is being told jokes by family members and friends to soften the blow of the occasion!

OPPOSITE
Manjunatha Temple, an animist shrine in Tamil Nadu. The priest is performing a *puja* in front of the village guardian and his two dog figures.

OVERLEAF
(LEFT) *Mahout* lovingly decorating his elephant with chalk for a temple festival.

(RIGHT) Woman praying for fertility, lighting a *puja* fire.

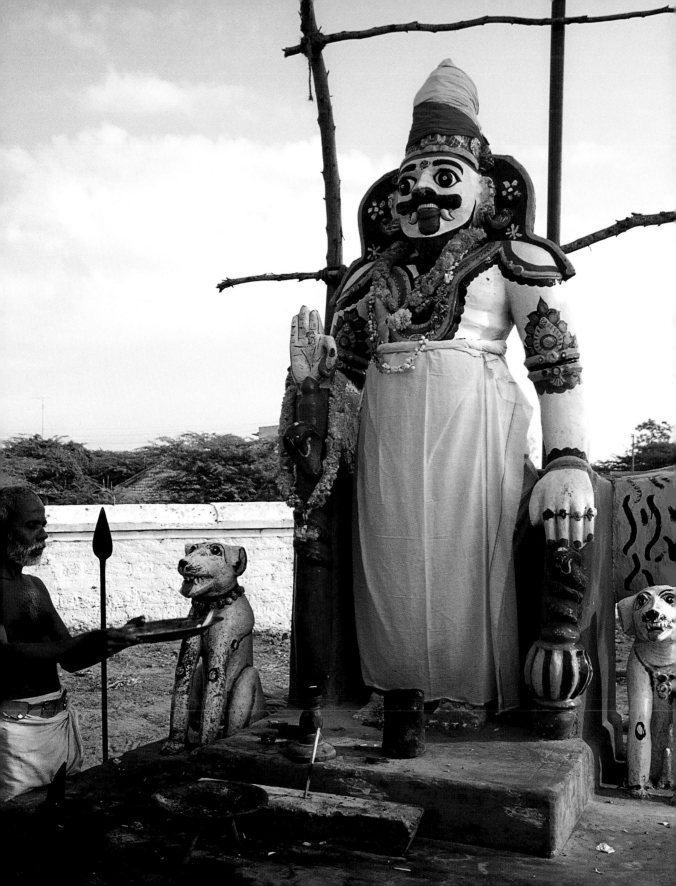

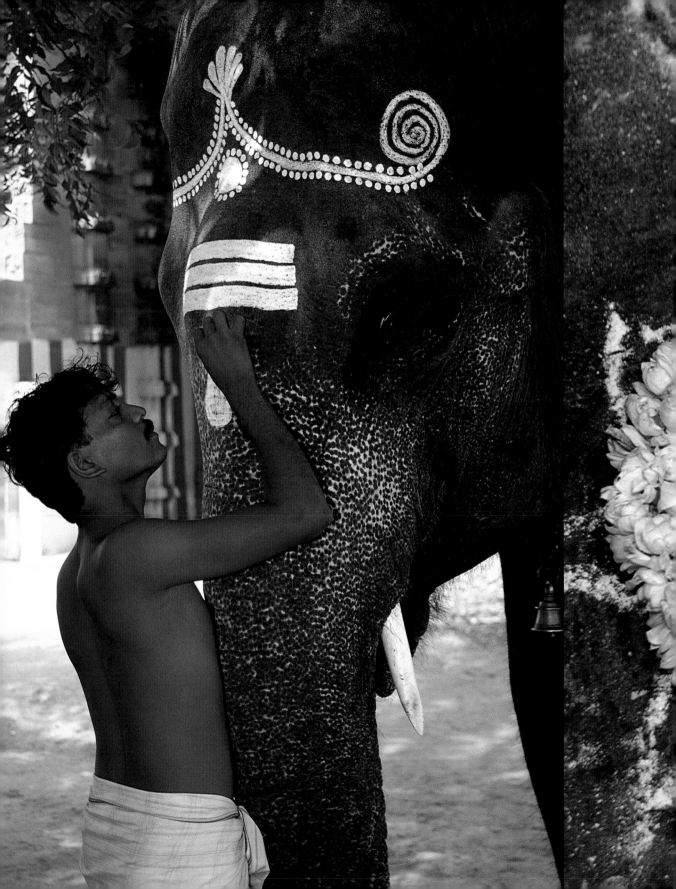

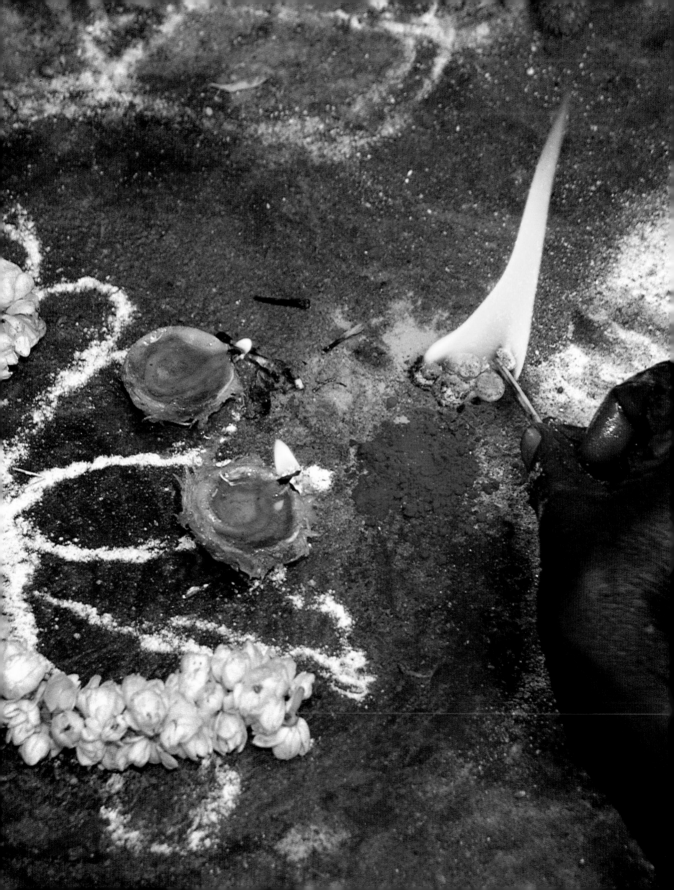

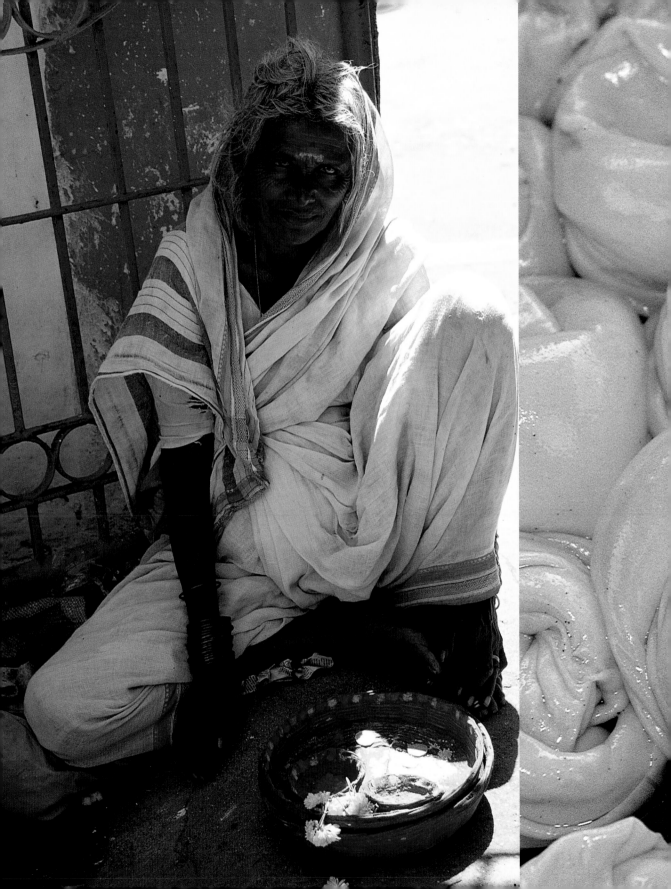

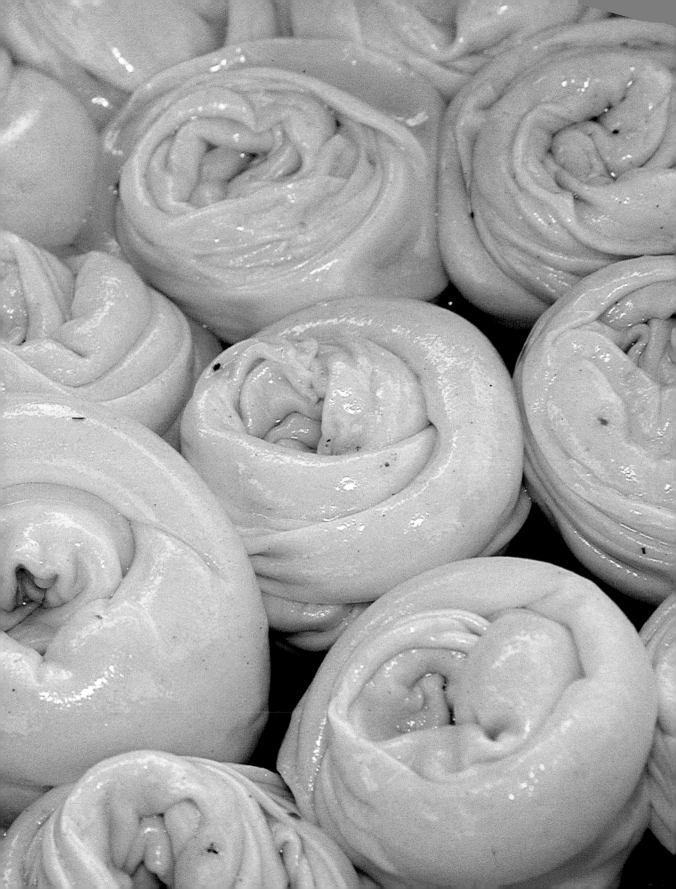

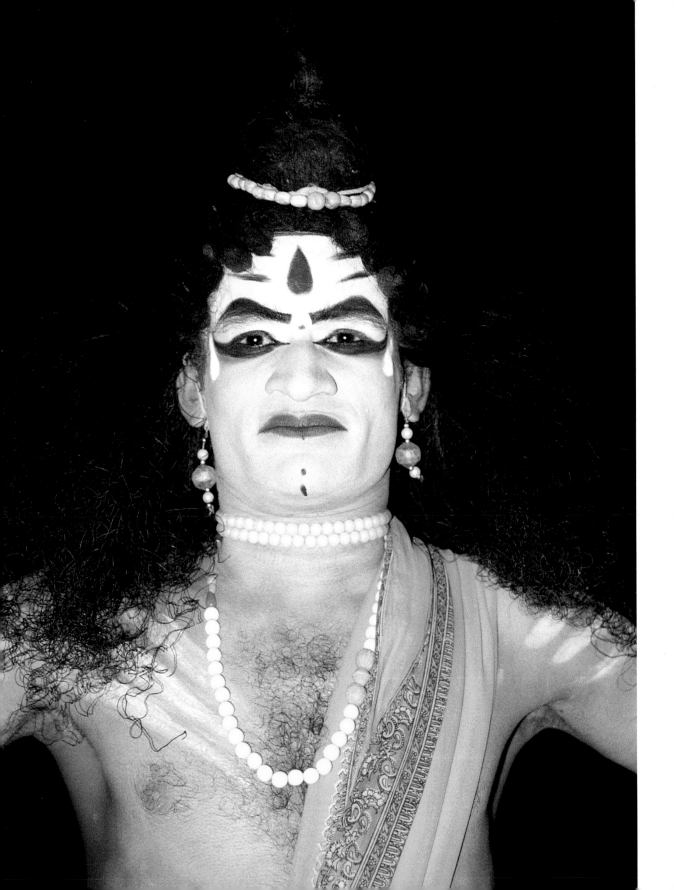

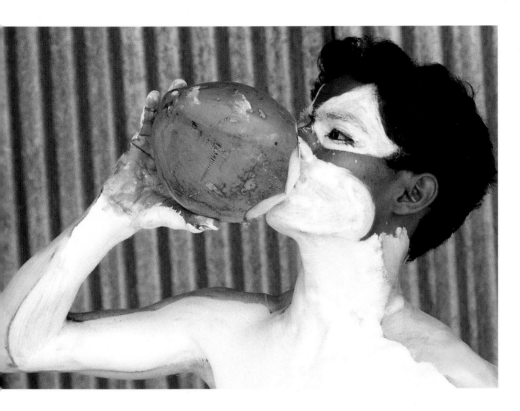

PREVIOUS PAGES
(LEFT) The Kali Galemmana
Gudi Temple in Hospet,
Karnataka: a female
worshipper of the goddess
Kali begs at the gates.

(RIGHT) Oiled dough
used for *parathas*,
ready for cooking.

OPPOSITE
Yakshagana dancer reciting
the *Ramayana*, which will
go on all night long.

LEFT
'Tiger' boy being decorated
to appear in a temple festival,
drinking from a coconut.
Once, the paint would
have been made of natural
pigments, but nowadays
household emulsion and
enamel are used.

green

Rice paddies rolling like life-enhancing waves across the plains. Colour of the freshness that follows the annual monsoon – life-giving waters to nurture the crops. Symbol of good in dance, token of fertility otherwise. Hope springs through its verdant shades.

Can the wind bring out
and publish for others
the fragrance
in the little bud?

Can even begetters, father and mother,
display for onlookers' eyes
the future breast and flowing hair
in the little girl
about to be bride?

Only ripeness
can show consequence,

Rāmanātha.

DĒVARA DĀSIMAYYA 128

RIGHT
Doorway in the Badami
area, Karnataka.

OPPOSITE
The Lalitha Mahal Palace near
Mysore, Karnataka, reflected in
the waters of its lily pond.

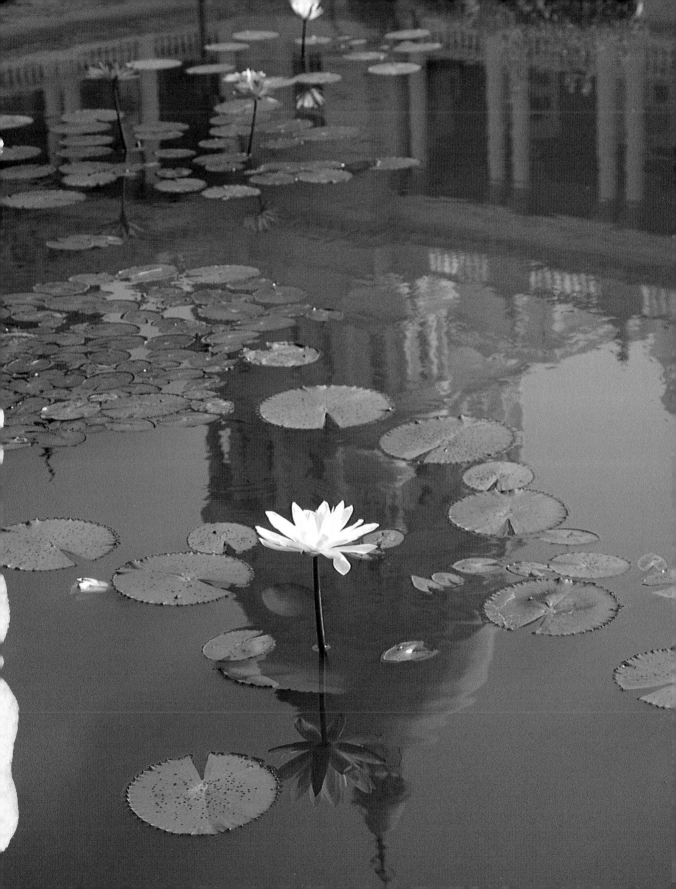

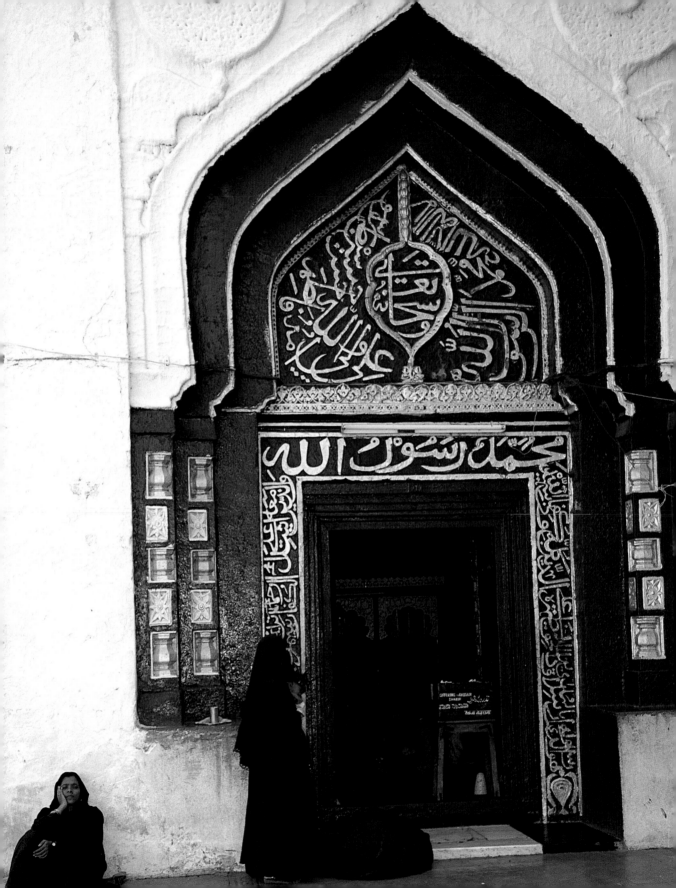

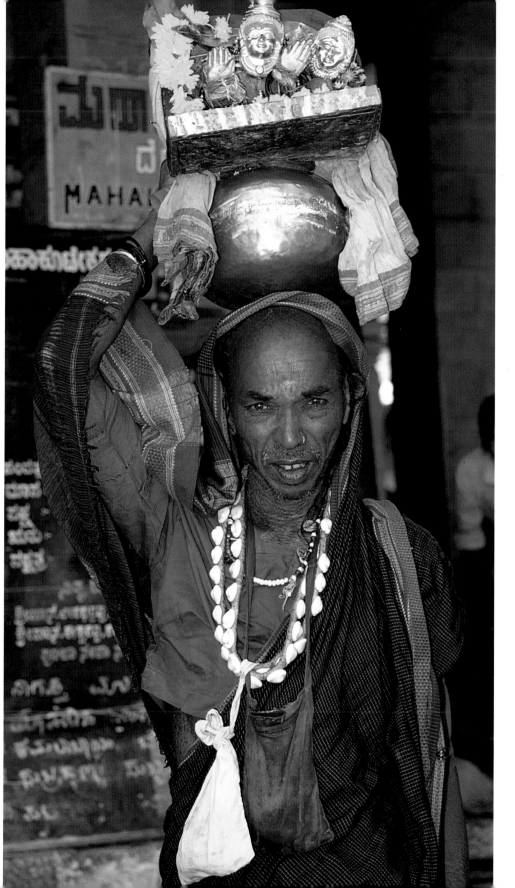

PREVIOUS PAGES
(LEFT) Small green
peppers in the market.

(RIGHT) Betel leaves.

OPPOSITE
Women peering through
the doorway of the Jami
Masjid mosque at Gulbarga,
Karnataka.

LEFT
This transvestite eunuch bears
a small shrine to the goddess
Kali on his head.

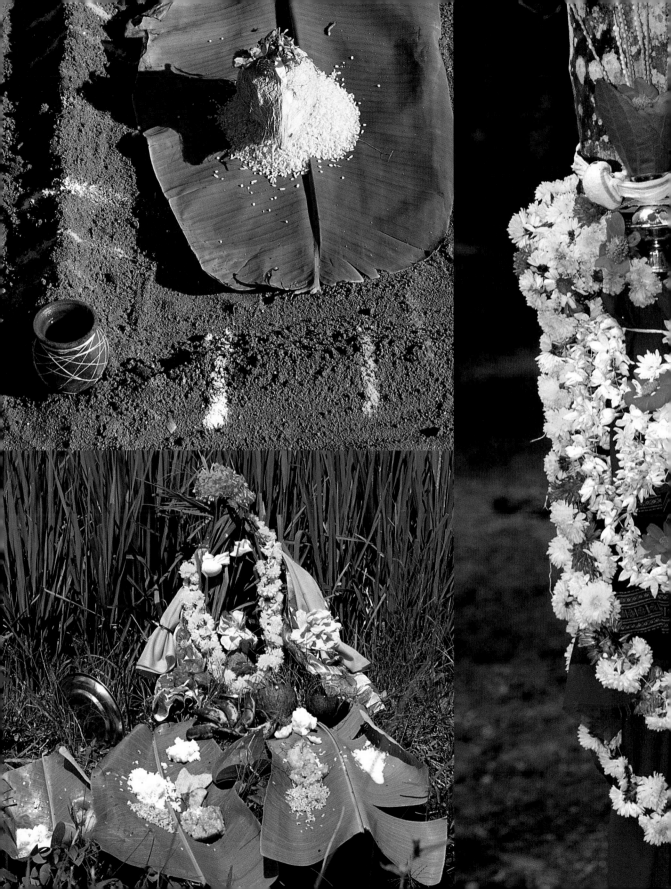

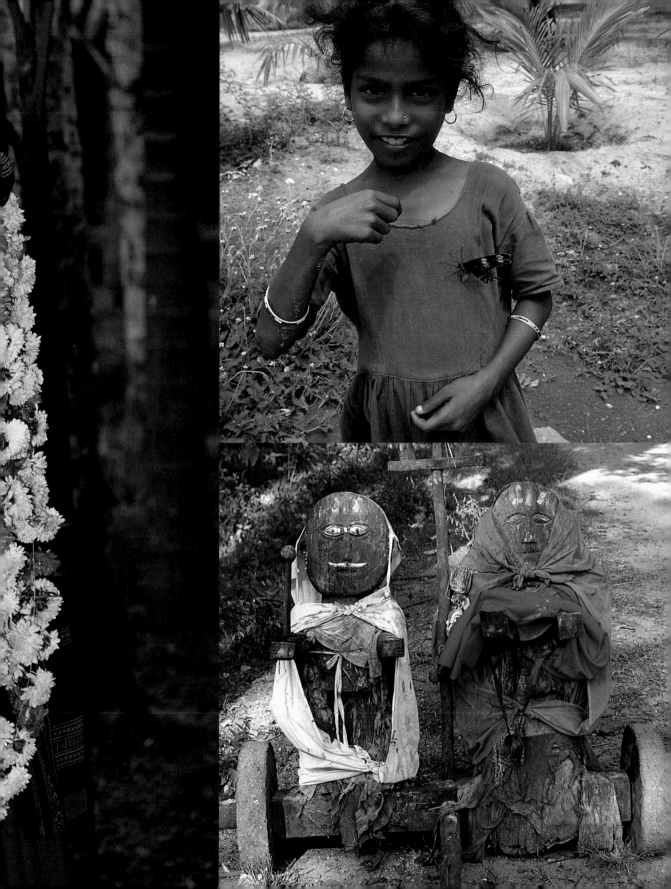

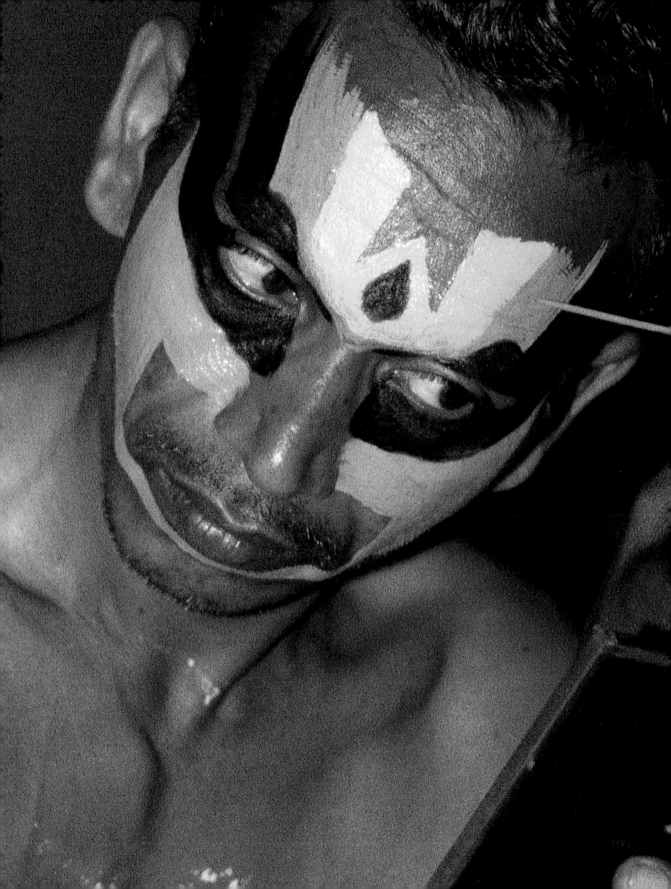

PREVIOUS PAGES

1 At Trichy (Tiruchchirappalli), Tamil Nadu, this is part of the ritual of worshipping departed family members on the Kaveri ghats. Small shrines are created in the sand with clay pots, betel leaves, rice and coloured powders.

2 The Bhoomi Hunnime Festival in a remote area of Karnataka. Celebrated on the day of the full moon between the Navarathri and Divali festivals, the rice fields are thanked for their harvest and shrines are made of the rice itself.

3 A betel tree is worshipped on the occasion of the Bhoomi Hunnime Festival, when the tree is dressed as a woman, in a sari. The whole family turns out with a picnic in the cool shade of the betel forest to celebrate this festival.

4 This little girl has a pet butterfly attached to her dress with thread. Children are still very inventive here!

5 These figures are animist guardians, taken on foot from their village in the night to expel evil spirits. The female figure is called Maramala.

LEFT
A *Kathakali* dancer prepares for his performance in Kerala. The colours he is applying to his face are made of natural ingredients. In this dance, green symbolizes a good character.

OVERLEAF
The tank at Ganga Kallyani, a remote village in Karnataka which is unrecorded in any guidebook. A place of simplicity and beauty.

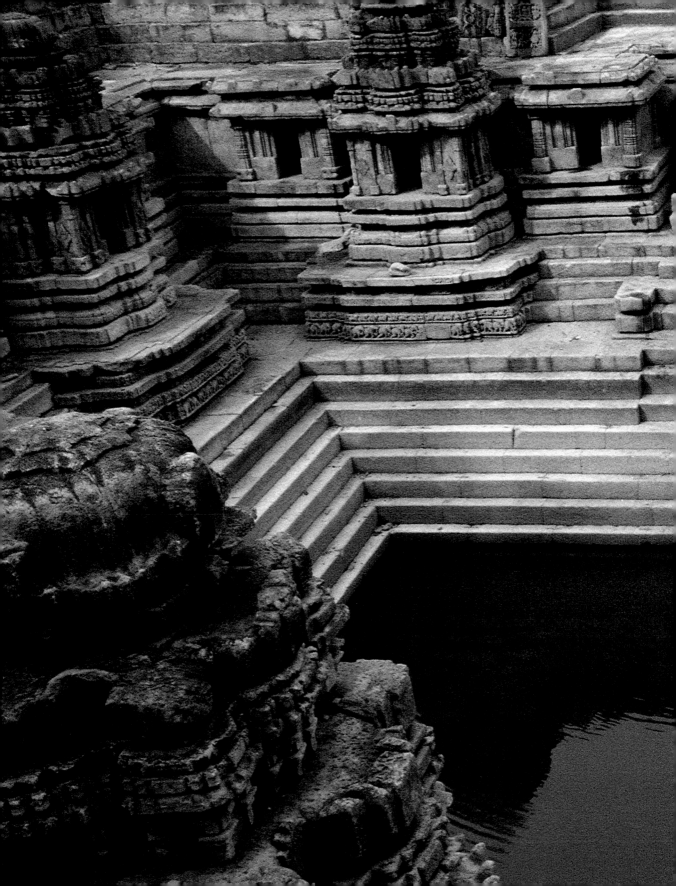

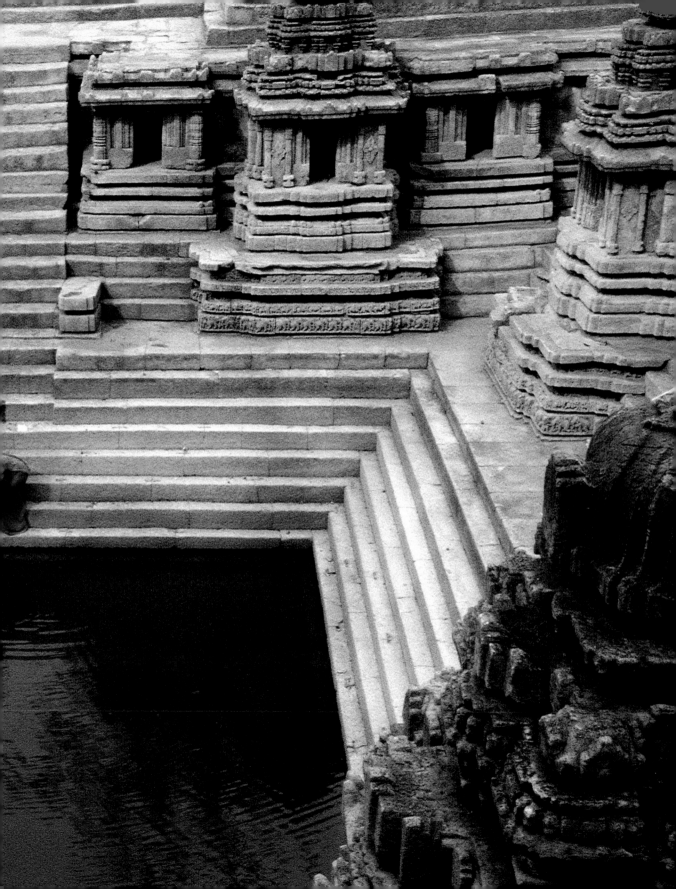

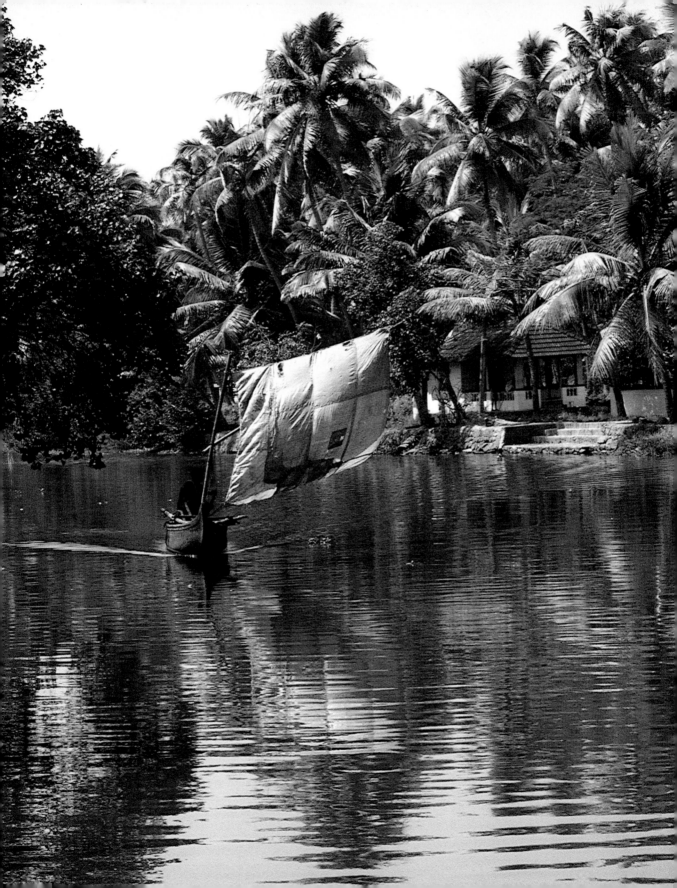

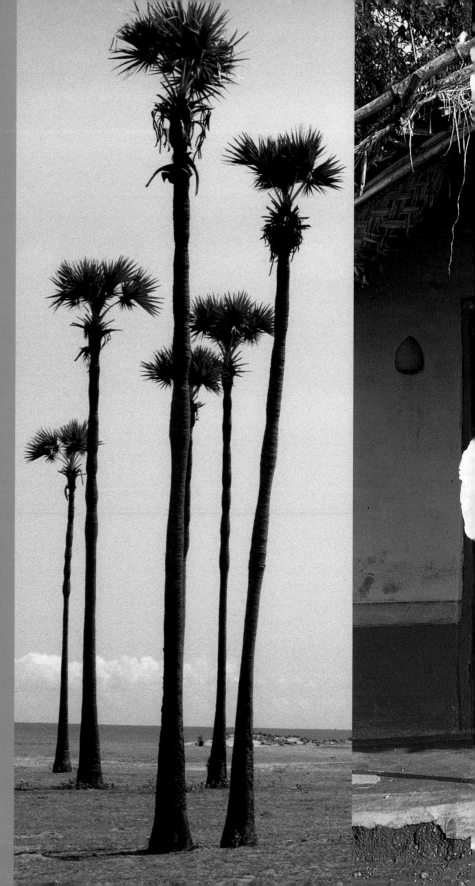

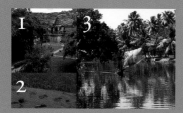

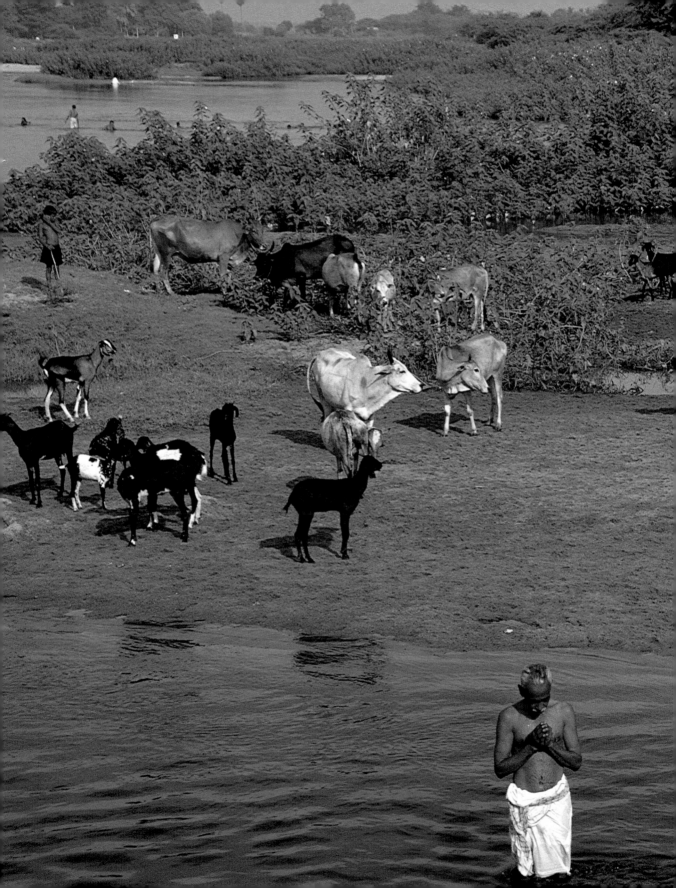

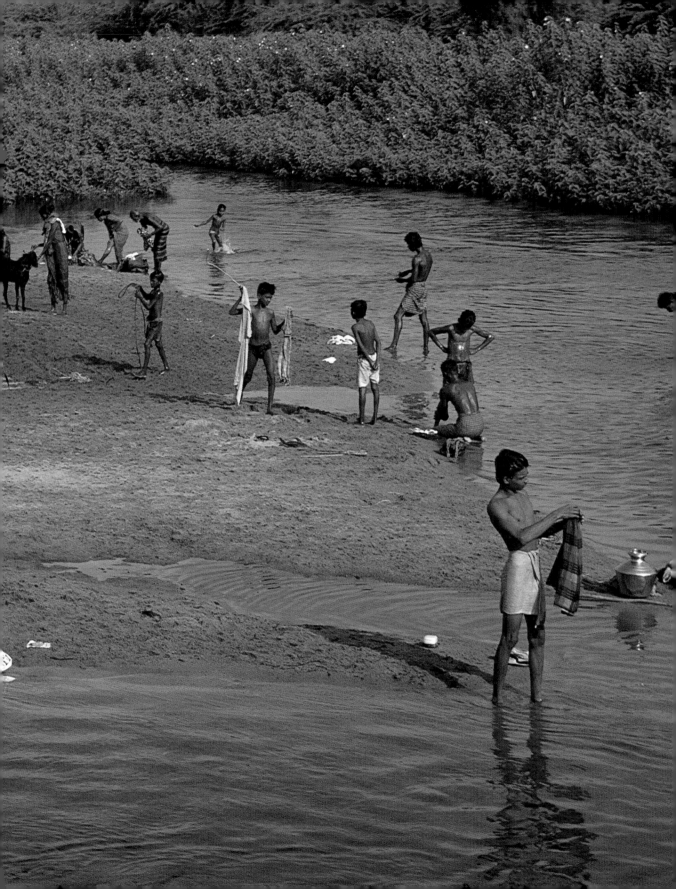

blue

Shimmering, reflecting, blue
water and ultramarine skies – hot
light refracting, waters retracting.
Sun and heat, life and energy.
Robin blue of the laundry making
its way into every village. Krishna
and his follies. The blue of
animism and of the cosmos –
deep blue of the night sky.
Clothes drying. Symbol of life.

You balanced the globe
 on the waters
 and kept it from melting away,

you made the sky stand
 without pillar or prop.

O Rāmanātha,
 which gods could have
 done this?

DĒVARA DĀSIMAYYA 4

RIGHT
Interior of a mosque, Calicut
(Kozhikode), Kerala.

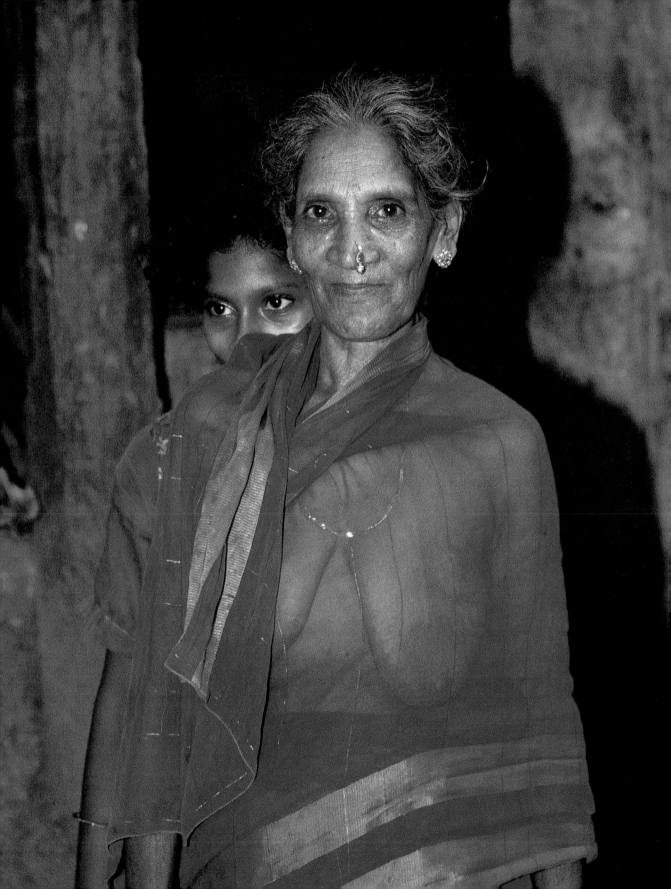

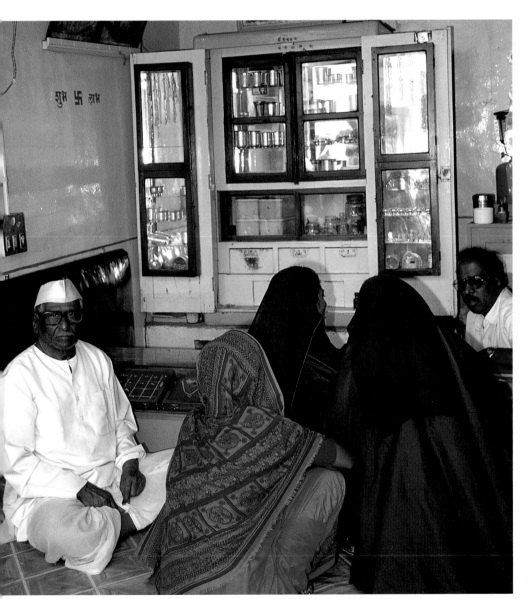

OPPOSITE
Elderly woman wearing her
sari in the traditional style.

LEFT
Muslim shoppers in a
Gulbarga jewelry store,
northern Karnataka.

OVERLEAF
The Western Ghats
(mountains) between Madurai
and Kodaikanal, Tamil Nadu.

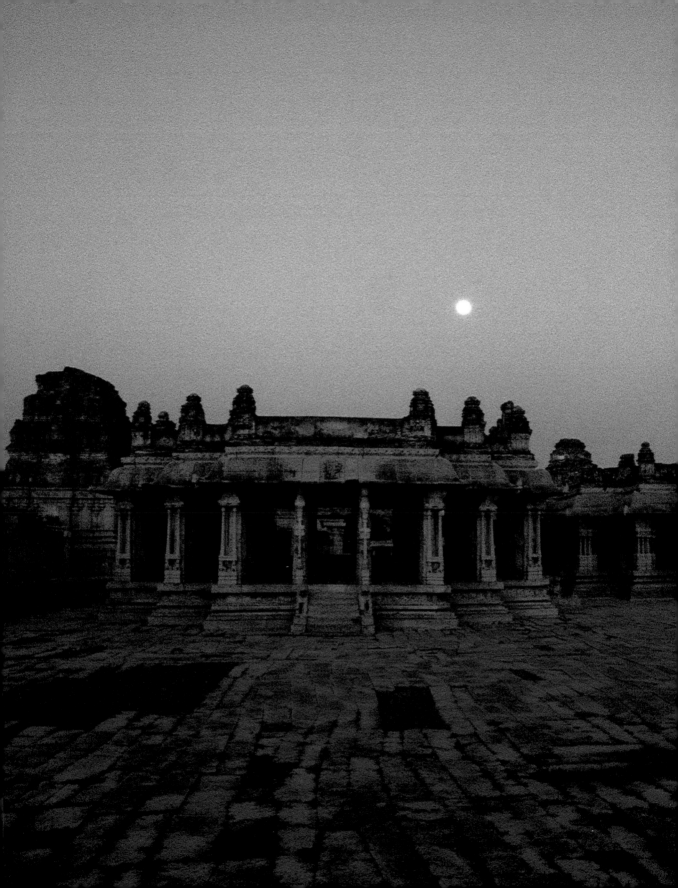

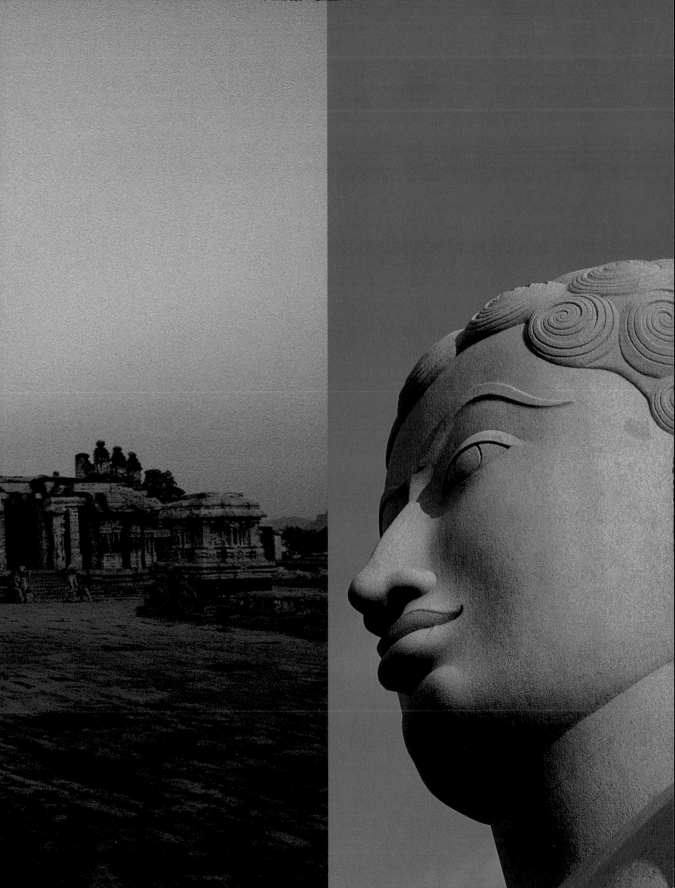

PREVIOUS PAGES

(LEFT) Full moon over
Vitthala Temple, Hampi
(Vijayanagara), Karnataka.

(RIGHT) The fine head of
the giant Gommateshvara
monolith, Sravana Belgola,
Karnataka.

RIGHT

A Muslim woman peers
through a screen into the
heart of a mosque. Women
are not allowed into the inner
sanctum. Tied to the screen
with threads are small parcels
which have been placed there
with special fertility prayers.

OPPOSITE

Tribal woman of the
Lombardi caste. Originally
from Rajasthan, these people
came south in search of
employment many centuries
ago and now number millions.
In the old days, the arm
bands were of bone, but now
they are mostly plastic. This
caste still supplies cheap
labour in the South.

OVERLEAF

(LEFT) Holy man in
Mahabalipuram
(Mamallapuram),
Tamil Nadu.

(RIGHT) Near Tadpatri,
Andhra Pradesh, houses
are painted in a distinctly
original way.

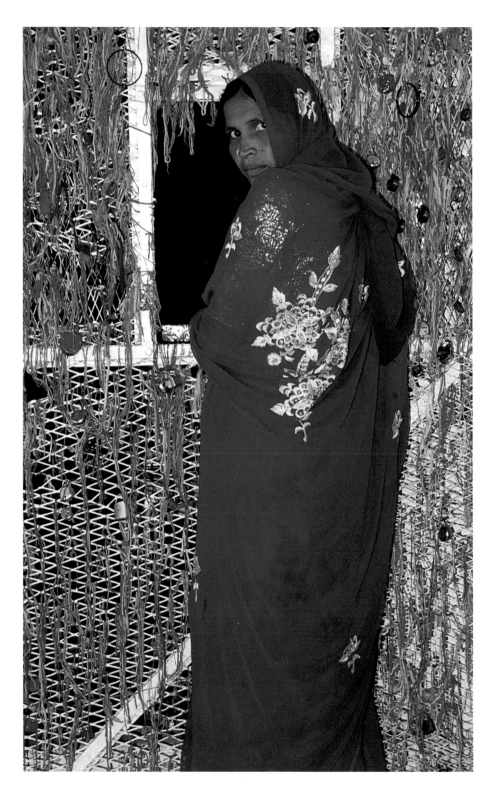

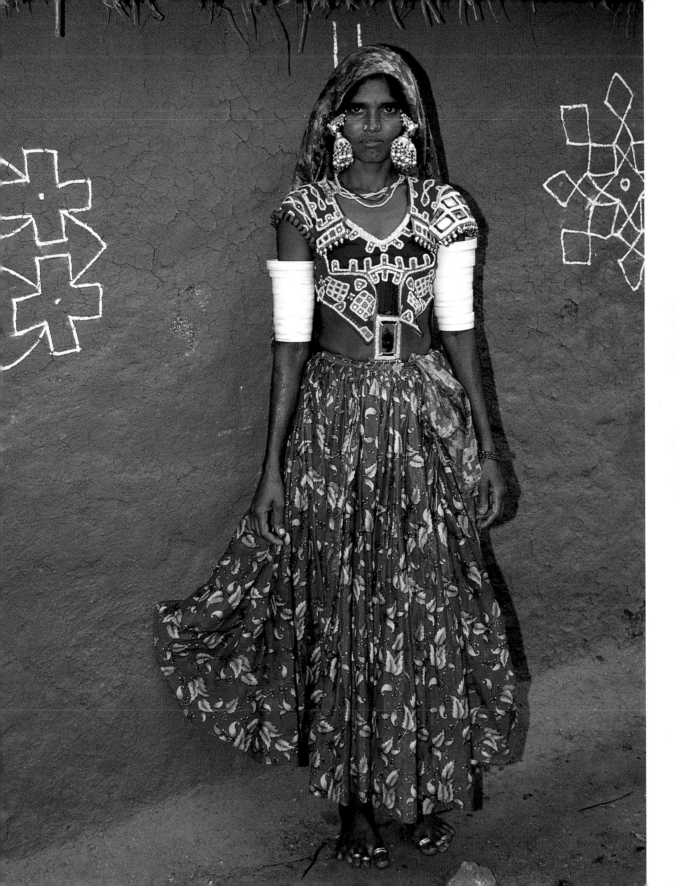

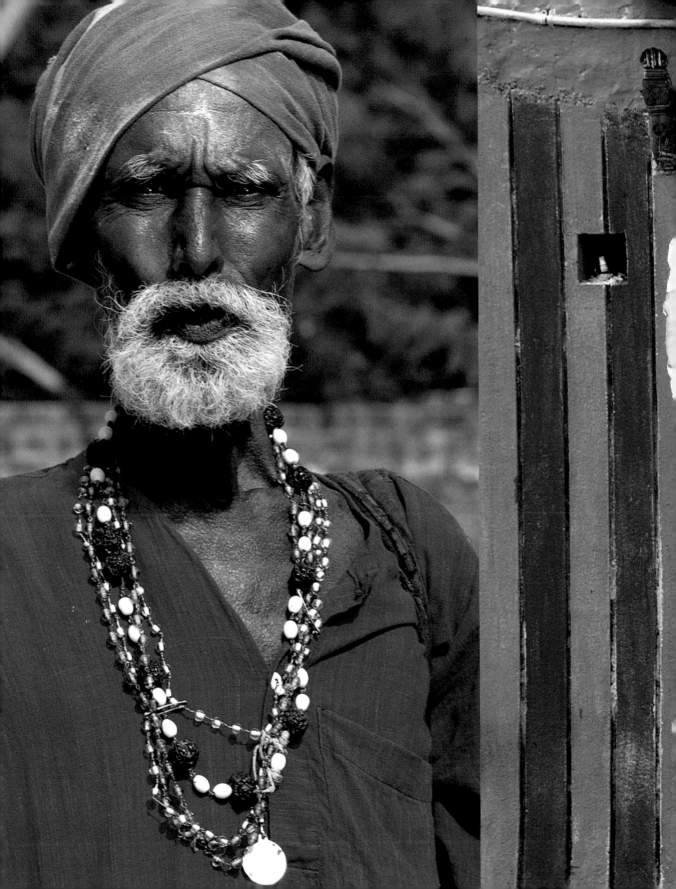

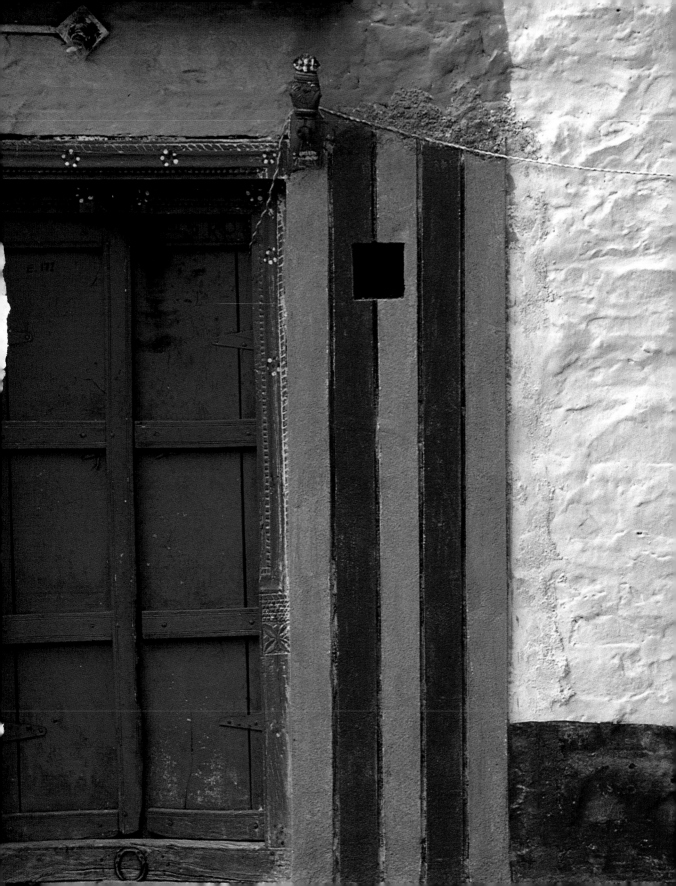

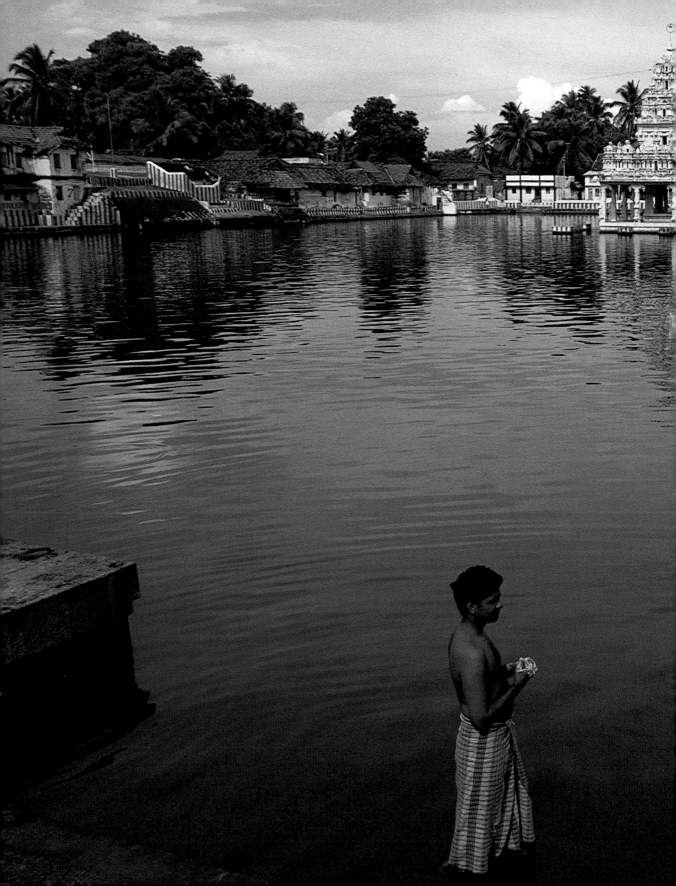

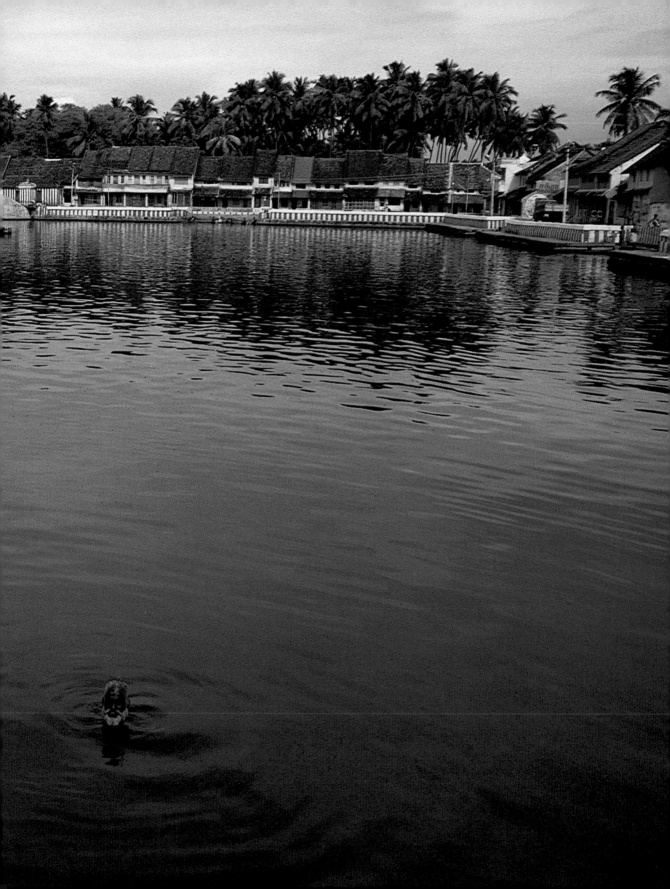

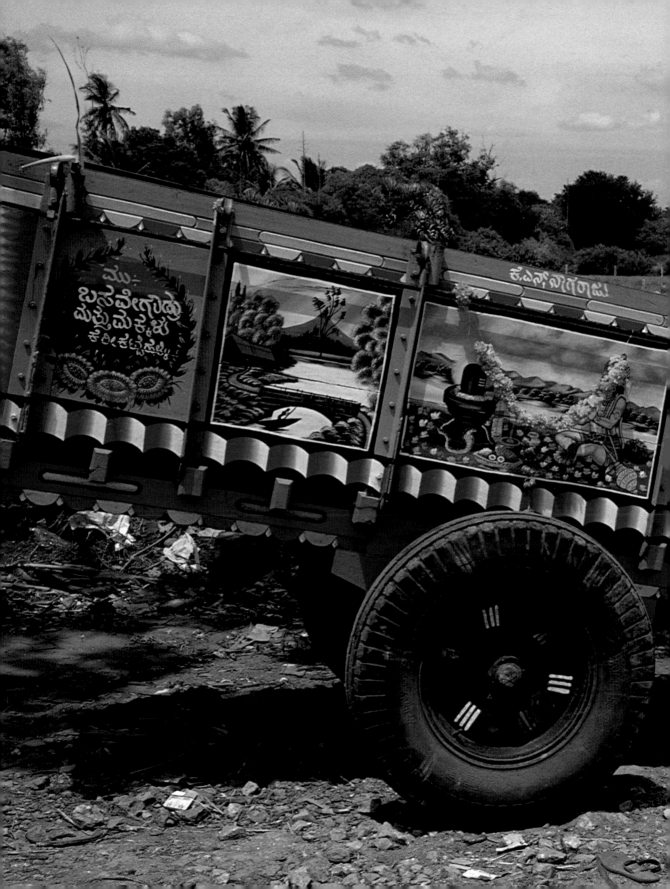

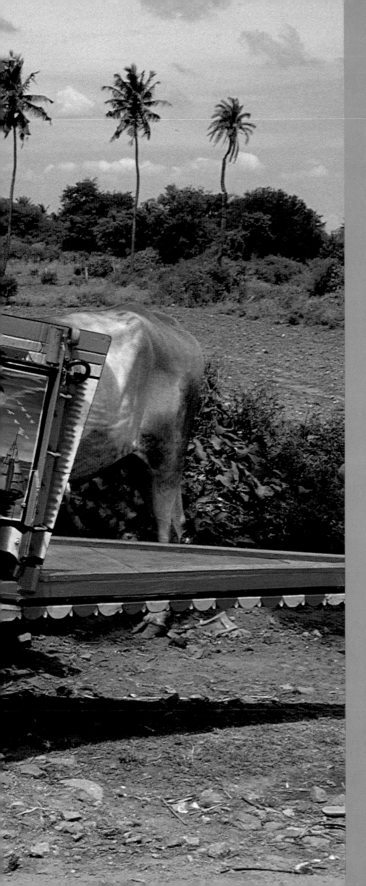

PREVIOUS PAGES
Tank of the Sthanumalaya
Temple, Suchindram,
Tamil Nadu.

LEFT
Bullock carts in this northern
part of Karnataka, near Belur,
are painted with the most
beautiful designs.

BELOW
Purple *dum dum* powder in
Mysore market, Karnataka.

OVERLEAF
Saris drying on the
beach, Karnataka coast.

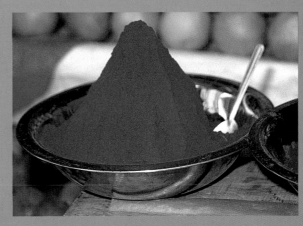

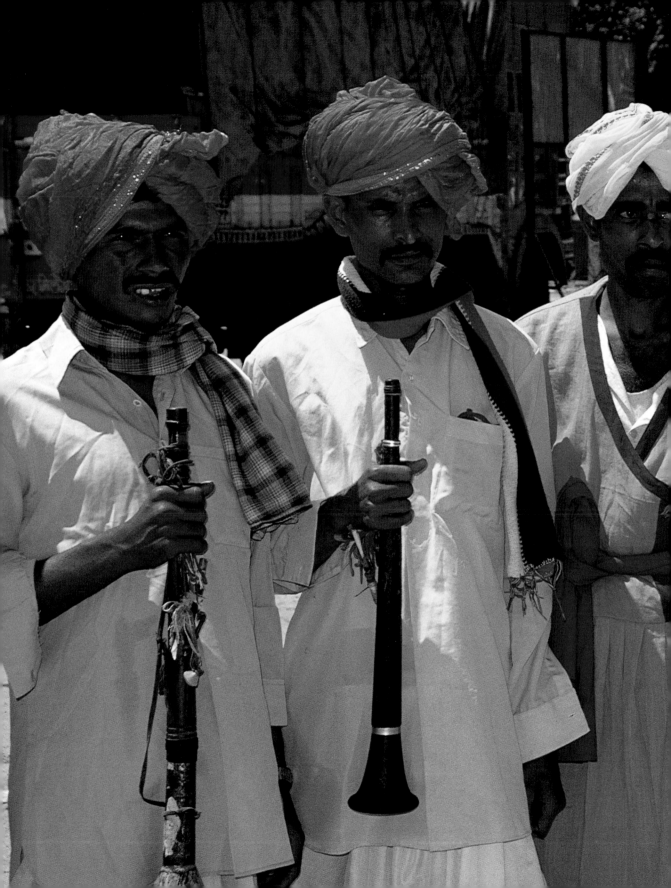

Crowds milling, chanting,
laughing. Life. Life vibrating
in the multitude of souls – hot
clothes and steaming bodies.
Heat and exuberance. Vitality,
joy. The plenitude of human
experience. Bodies packed
together tightly. Elephants.
Music and festivals celebrating
the joy of being alive.

Make of my body the beam of a lute
 of my head the sounding gourd
 of my nerves the strings
 of my fingers the plucking rods.

Clutch me close
 and play your thirty-two songs
 O lord of the meeting rivers!

BASAVANNA 500

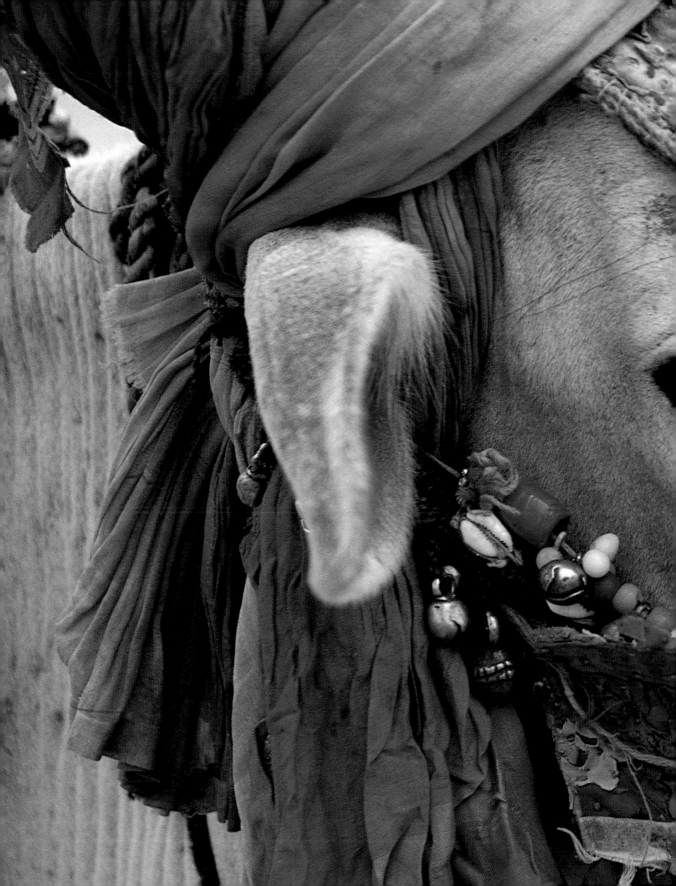

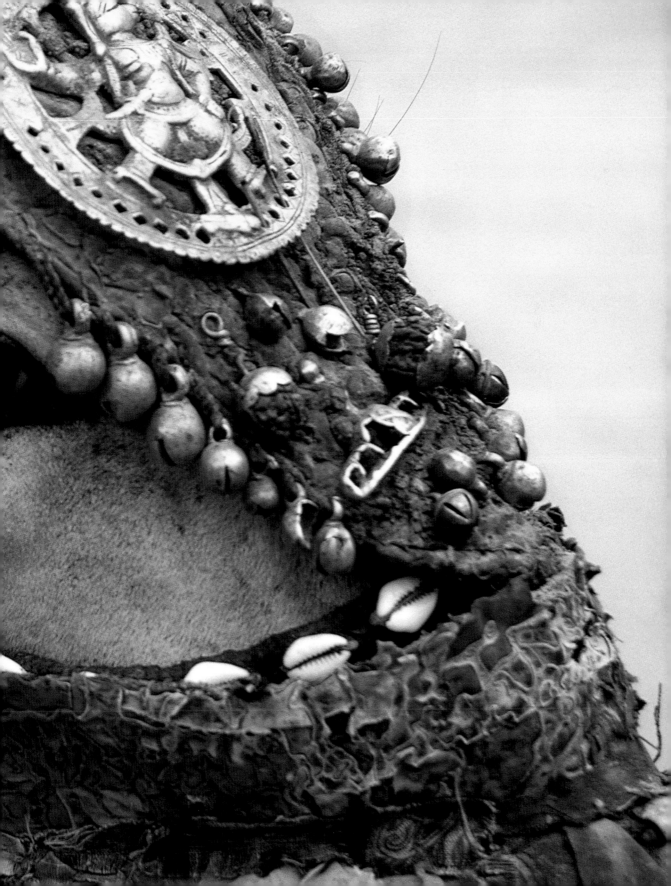

PREVIOUS PAGES
Holy cow.

RIGHT
The devil in a *Kathakali* dance
performance in Kerala.

OPPOSITE
Tribal woman of the Lombardi
caste with her child. They have
the most wonderful jewelry
with mirrors, coins, brass,
silver and tassles. Kerala.

OVERLEAF
This small modern temple in
Andhra Pradesh is dedicated
to the goddess Kali.

PAGES 144-145
Musicians in their finery
attending the Dussera Festival
in Mysore, Karnataka.

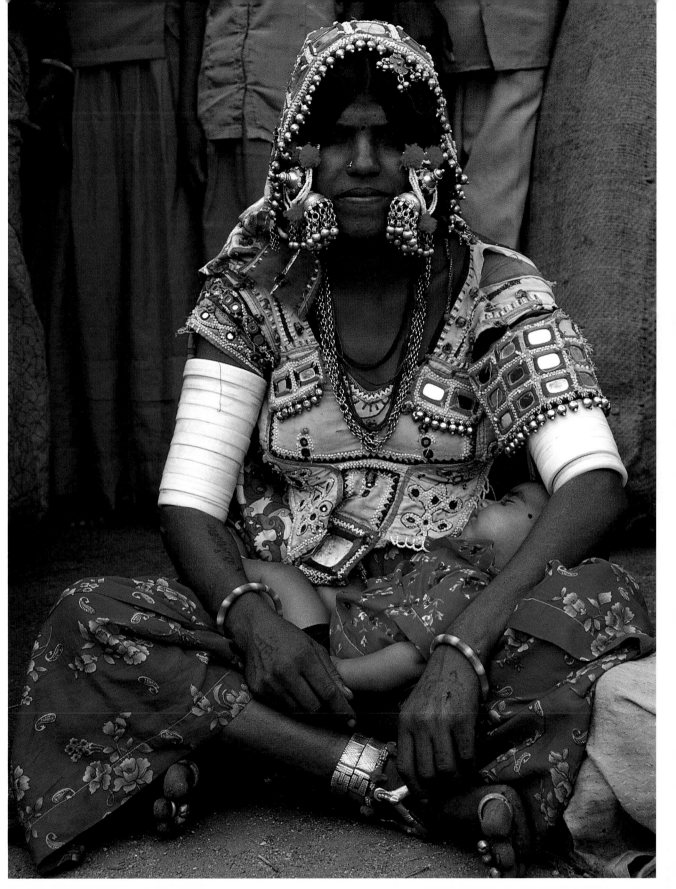

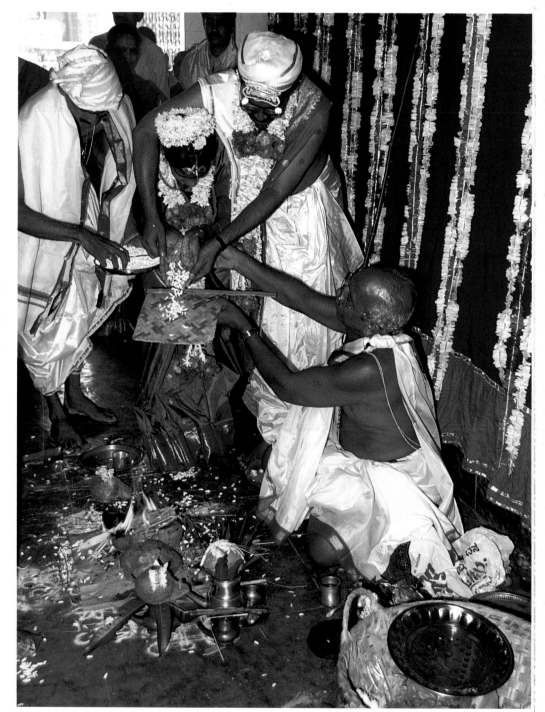

RIGHT
Part of the wedding rites in Karnataka, where the priest pours puffed rice between the joined hands of the bride and groom.

OPPOSITE
Crowds attending the blessing of a temple in Madras (Chennai), Tamil Nadu.

OVERLEAF
(LEFT) A fully decorated temple elephant.

(RIGHT) *Rangoli* (floor painting with powders) in the form of oil lamps.

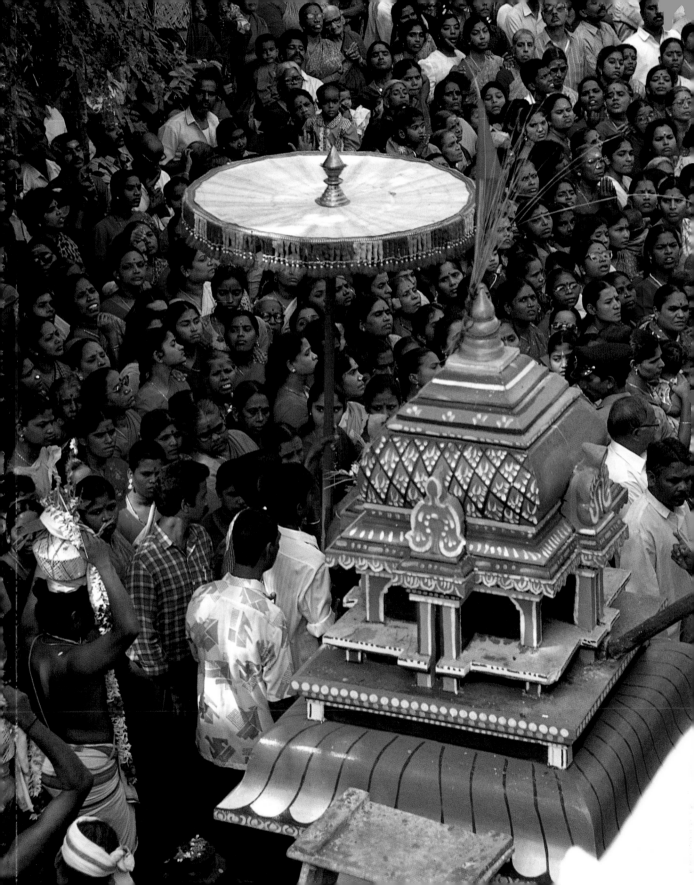

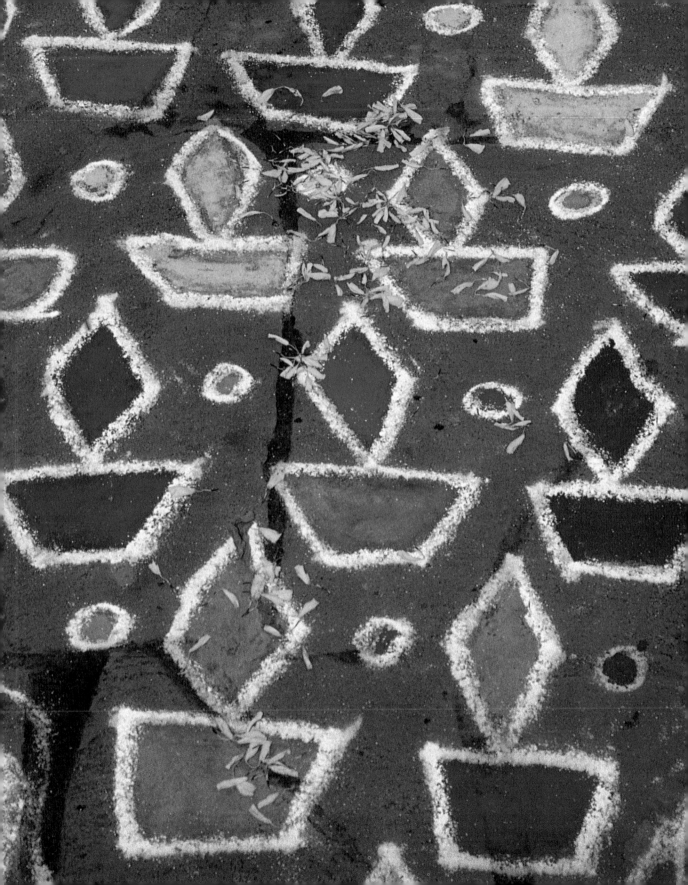

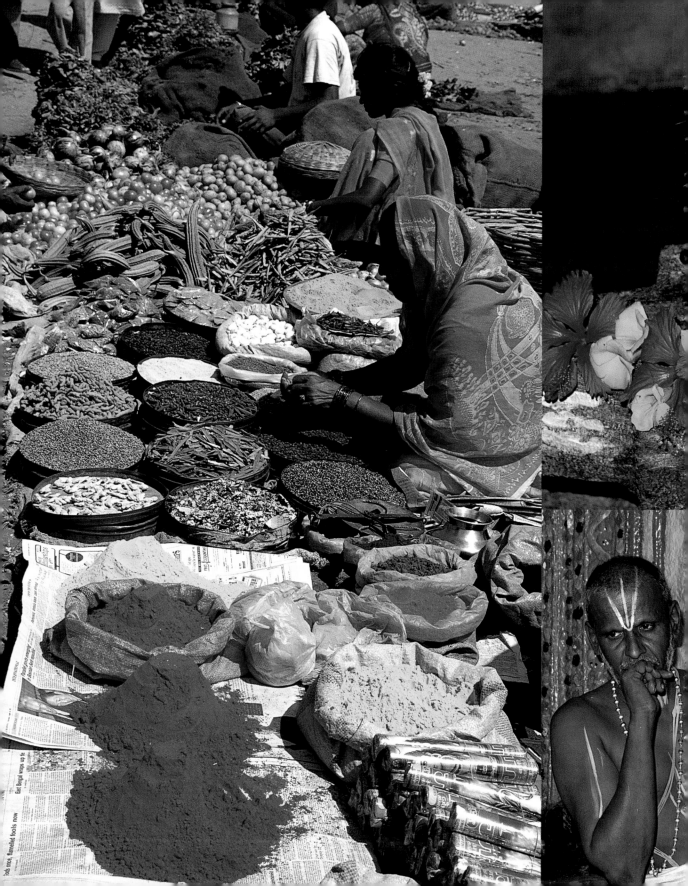

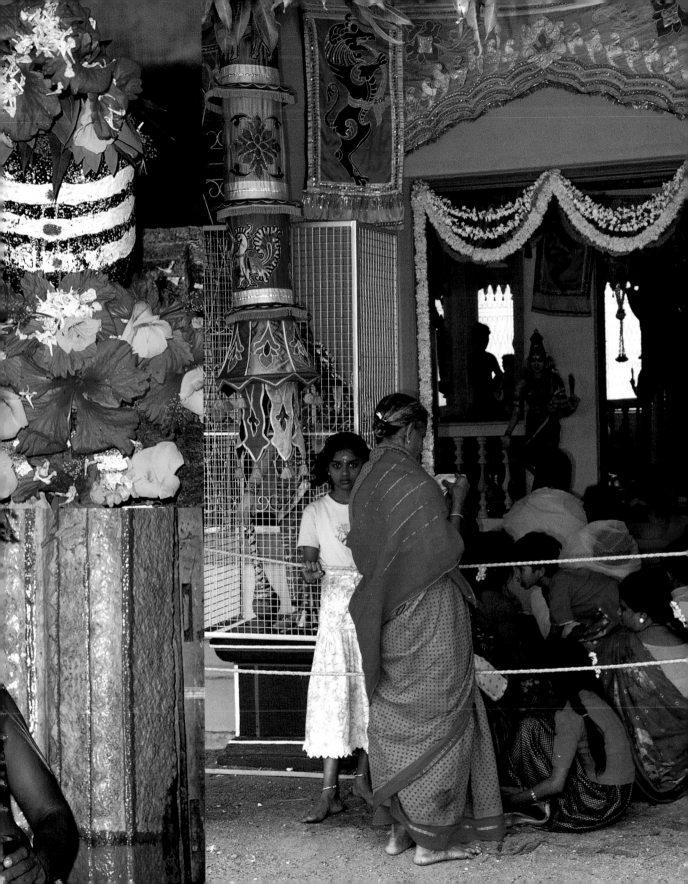

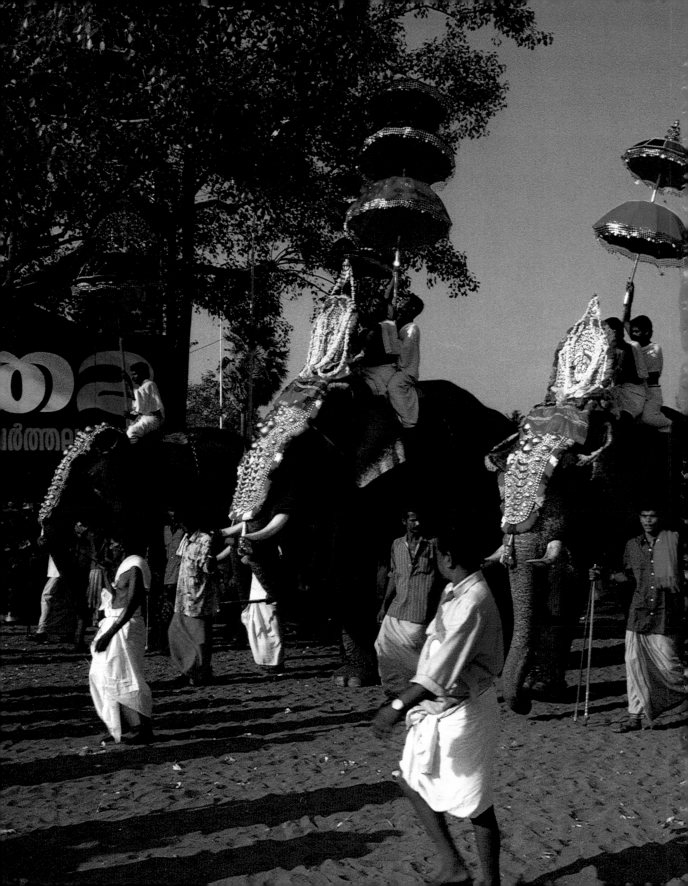